INFORMATION DASHBOARD DESIGN

The Effective Visual Communication of Data

STEPHEN FEW

O'REILLY®

Beijing • Cambridge • Köln • London • Sebastopol • Taipei • Tokyo

INFORMATION DASHBOARD DESIGN

by Stephen Few

Copyright © 2006 Stephen Few
All rights reserved.
Printed in Italy.

Published by O'Reilly Media, Inc.
1005 Gravenstein Highway North
Sebastopol, CA 95472

O'Reilly books may be purchased for educational, business, or sales promotional use. Online editions are also available for most titles (*safari.oreilly.com*). For more information, contact our corporate/institutional sales department: 800-998-9938 or *corporate@oreilly.com*.

EDITOR	Colleen Wheeler
PRODUCTION EDITOR	Genevieve d'Entremont
ART DIRECTOR	Mike Kohnke
COVER DESIGNER	Stephen Few
INTERIOR DESIGNERS	Mike Kohnke, Terri Driscoll
PRODUCTION SERVICES	Specialized Composition, Inc.

Print History
 January 2006: First Edition.

978-0-596-10016-2

[L] [11/11]

To my parents, Bob and Joyce Few, whose pride in my journey—however strange that journey must have sometimes seemed—instilled deep down into my bones the resolve to keep placing one foot in front of the other.

CONTENTS

Few phenomena characterize our time more uniquely and powerfully than the rapid rise and influence of information technologies. These technologies have unleashed a tsunami of data that rolls over and flattens us in its wake. Taming this beast has become a primary goal of the information industry. One tool that has emerged from this effort in recent years is the information dashboard. This single-screen display of the most important information people need to do a job, presented in a way that allows them to monitor what's going on in an instant, is a powerful new medium of communication. At least it can be, but only when properly designed.

Most information dashboards that are used in business today fall far short of their potential. The root of the problem is not technology—at least not primarily—but poor visual design. To serve their purpose and fulfill their potential, dashboards must display a dense array of information in a small amount of space in a manner that communicates clearly and immediately. This requires design that taps into and leverages the power of visual perception to sense and process large chunks of information rapidly. This can be achieved only when the visual design of dashboards is central to the development process and is informed by a solid understanding of visual perception—what works, what doesn't, and why.

No technology can do this for you. You must bring this expertise to the process. Take heart—the visual design skills that you need to develop effective dashboards can be learned, and helping you learn them is the sole purpose of this book.

If the information is important, it deserves to be communicated well.

ACKNOWLEDGMENTS

Without a doubt I owe the greatest debt of gratitude to the many software vendors who have done so much to make this book necessary by failing to address or even contemplate the visual design needs of dashboards. Their kind disregard for visual design has given me focus, ignited my passion, and guaranteed my livelihood for years to come.

Now, on to those who have contributed more directly and personally to this effort. As a man, I will never be able to create, shelter, and nourish an emerging life within this body of mine. In recent years, however, I have recognized and pursued the opportunity to breathe life into the products of my imagination and pass them on to the world in the form of books. Writing a book is a bit like bearing a child. Working with a publisher to help the child learn to walk before venturing into the world is a lesson in trust. The folks at O'Reilly Media have taught me to entrust to them— beginning with unspeakable angst, but proceeding through unfaltering steps toward ever-increasing comfort—the collegial care of this beloved child. Many at O'Reilly have contributed so much, but two in particular have stood by my side from the beginning with soothing voices of confidence and calm. My editor, Colleen Wheeler, knew when to listen in silence, when to tease me out of myopia, and when to gently remind me that I was in her considerate and considerable care. My acquisitions editor, Steve Weiss, sought me out and wooed me through months of thoughtful discussion into the O'Reilly fold. He gave assurances and has made sure that they were fulfilled.

1

CLARIFYING THE VISION

Dashboards offer a unique and powerful solution to an organization's need for information, but they usually fall far short of their potential. Dashboards must be seen in historical context to understand and appreciate how and why they've come about, why they've become so popular, and why—despite many problems that undermine their value today—they offer benefits worth pursuing. To date, little serious attention has been given to their visual design. This book strives to fill this gap. However, confusion abounds, demanding a clear definition of dashboards before we can explore the visual design principles and practices that must be applied if they are to live up to their unique promise.

Above all else, this is a book about communication. It focuses exclusively on a particular medium of communication called a *dashboard*. In the fast-paced world of information technology (IT), terms are constantly changing. Just when you think you've wrapped your mind around the latest innovation, the technology landscape shifts beneath you and you must struggle to remain upright. This is certainly true of dashboards.

Live your life on the surface of these shifting sands, and you'll never get your balance. Look a little deeper, however, and you'll discover more stable ground: a bedrock of objectives, principles, and practices for information handling that remains relatively constant. Dashboards are unique in several exciting and useful ways, but despite the hype surrounding them, what they are and how they work as a means of delivering information are closely related to some long-familiar concepts and technologies. It's time to cut through the hype and learn the practical skills that can help you transform dashboards from yet another fad riding the waves of the technology buzz into the effective means to enlighten that they really can be.

Today, everybody wants a dashboard. Like many newcomers to the technology scene, dashboards are sexy. Software vendors work hard to make their dashboards shimmy with sex appeal. They taunt, "You don't want to be the only company in your neighborhood without one, do you?"

They warn, "You can no longer live without one." They whisper sweetly, "Still haven't achieved the expected return on investment (ROI) from your expensive data warehouse? Just stick a dashboard in front of it and watch the money pour in." Be still my heart.

Those gauges, meters, and traffic lights are so damn flashy! You can imagine that you're sitting behind the wheel of a German-engineered sports car, feeling the wind whip through your hair as you tear around curves on the autobahn at high speeds, all without leaving your desk.

Everyone wants a dashboard today, but often for the wrong reasons. Rest assured, however, that somewhere beyond the hype and sizzle lives a unique and effective solution to familiar business problems that are rooted in a very real need for information. That's the dashboard that deserves to live on your screen.

All That Glitters Is Not Gold

Dashboards can provide a unique and powerful means to present information, but they rarely live up to their potential. Most dashboards fail to communicate efficiently and effectively, not because of inadequate technology (at least not primarily), but because of poorly designed implementations. No matter how great the technology, a dashboard's success as a medium of communication is a product of design, a result of a display that speaks clearly and immediately. Dashboards can tap into the tremendous power of visual perception to communicate, but only if those who implement them understand visual perception and apply that understanding through design principles and practices that are aligned with the way people see and think. Software won't do this for you. It's up to you.

Unfortunately, most vendors that provide dashboard software have done little to encourage the effective use of this medium. They focus their marketing efforts on flash and dazzle that subvert the goals of clear communication. They fight to win our interest by maximizing sizzle, highlighting flashy display mechanisms that appeal to our desire to be entertained. Once implemented, however, these cute displays lose their spark in a matter of days and become just plain annoying. An effective dashboard is the product not of cute gauges, meters, and traffic lights (Figure 1-1), but rather of informed design: more science than art, more simplicity than dazzle. It is, above all else, about communication.

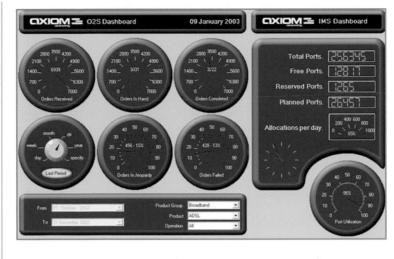

Figure 1-1. A typical flashy dashboard. Can't you just feel the engine revving?

This failure by software vendors to focus on what we actually *need* is hardly unique to dashboards. Most software suffers from the same short-coming—despite all the hype about user-friendliness, it is difficult to use. This sad state is so common, and has been the case for so long, we've grown accustomed to the pain. On those occasions when this ugly truth breeches the surface of our consciousness, we usually blame the problem on ourselves rather than the software, framing it in terms of "computer illiteracy." If we could only adapt more to the computer and how it works, there wouldn't be a problem—or so we reason. In his insightful book entitled *The Inmates Are Running the Asylum*, master designer Alan Cooper writes:

> The sad thing about dancing bearware [Cooper's term for poorly designed software that is difficult to use] is that most people are quite satisfied with the lumbering beast. Only when they see some real dancing do they begin to suspect that there is a world beyond ursine shuffling. So few software-based products have exhibited any real dancing ability that most people are honestly unaware that things could be better—a lot better.

Alan Cooper, *The Inmates Are Running the Asylum* (Indianapolis, IN: SAMS Publishing, 1999), 59.

Cooper argues that this failure is rooted in an approach to software development that simply doesn't work. In a genuine attempt to please their customers, software engineers focus on checking all the items, one by one, off of lists of requested features. This approach makes sense to technology-oriented software engineers, but it results in lumbering beasts. Customers are expert in knowing what they need to accomplish, but not in knowing how software ought to be designed to support their needs. Allowing customers to design software through feature requests is the worst form of disaster by committee.

Software vendors should bring design vision and expertise to the development process. They ought to know the difference between superficial glitz and what really works. But they're so exhausted from working ungodly hours trying to squeeze more features into the next release that they're left with no time to do the research needed to discover what actually works, or even to step back and observe how their products are really being used (and failing in the process).

The part of information technology that focuses on reporting and analysis currently goes by the name *business intelligence* (BI). To date, BI vendors have concentrated on developing the underlying technologies that are used to gather data from source systems, transform data into a more usable form, store data in high-performance databases, access data for use, and present data in the form of reports. Tremendous progress has been made in these areas, resulting in robust technologies that can handle huge repositories of data. However, while we have managed to warehouse a great deal of information, we have made little progress in using that information effectively. Relatively little effort has been dedicated to engaging human intelligence, which is what this industry, by definition, is supposed to be about.

A glossary on the Gartner Group's web site defines business intelligence as "An interactive process for exploring and analyzing structured, domain-specific information… to discern business trends or patterns, thereby deriving insights and drawing conclusions" (*http://www.gartner.com/6_help/glossary/GlossaryB.jsp*). To progress in this worthwhile venture, the BI industry must shift its focus now to an engaging interaction with human perception and intelligence. To do this, vendors must base their efforts on a firm understanding of how people perceive and think, building interfaces, visual displays, and methods of interaction that fit seamlessly with human ability.

Even Dashboards Have a History

In many respects, "dashboard" is simply a new name for the *Executive Information Systems* (EISs) first developed in the 1980s. These implementations remained exclusively in the offices of executives and never numbered more than a few, so it is unlikely that you've ever actually seen one. I sat through a few vendor demos back in the 1980s but never did see an actual system in use. The usual purpose of an EIS was to display a handful of key financial measures through a simple interface that "even an executive could understand." Though limited in scope, the goal was visionary and worthwhile, but ahead of its time. Back then, before data warehousing and business intelligence had evolved the necessary data-handling methodologies and given shape to the necessary technologies,

the vision simply wasn't practical; it couldn't be realized because the required information was incomplete, unreliable, and spread across too many disparate sources. Thus, in the same decade that the EIS arose, it also went into hibernation, preserving its vision in the shadows until the time was ripe... That is, until now.

During the 1990s, data warehousing, *online analytical processing* (OLAP), and eventually business intelligence worked as partners to tame the wild onslaught of the information age. The emphasis during those years was on collecting, correcting, integrating, storing, and accessing information in ways that sought to guarantee its accuracy, timeliness, and usefulness. From the early days of data warehousing on into the early years of this new millennium, the effort has largely focused on the technologies, and to a lesser degree the methodologies, needed to make information available and useful. The direct beneficiaries so far have mostly been folks who are highly proficient in the use of computers and able to use the available tools to navigate through large, often complex databases.

What also emerged in the early 1990s, but didn't become popular until late in that decade, was a new approach to management that involved the identification and use of *key performance indicators* (KPIs), introduced by Robert S. Kaplan and David P. Norton as the *Balanced Scorecard*. The advances in data warehousing and its technology partners set the stage for this new interest in management through the use of metrics—and not just financial metrics—that still dominates the business landscape today. *Business Performance Management* (BPM), as it is now commonly known, has become an international preoccupation. The infrastructure built by data warehousing and the like, as well as the interest of BPM in metrics that can be monitored easily, together tilled and fertilized the soil in which the hibernating seeds of EIS-type displays were once again able to grow.

What really caused heads to turn in recognition of dashboards as much more than your everyday fledgling technology, however, was the Enron scandal in 2001. The aftermath put new pressure on corporations to demonstrate their ability to closely monitor what was going on in their midst and to thereby assure shareholders that they were in control. This increased accountability, combined with the concurrent economic downturn, sent Chief Information Officers (CIOs) on a mission to find anything that could help managers at all levels more easily and efficiently keep an eye on performance. Most BI vendors that hadn't already started offering a dashboard product soon began to do so, sometimes by cleverly changing the name of an existing product, sometimes by quickly purchasing the rights to an existing product from a smaller vendor, and sometimes by cobbling together pieces of products that already existed. The marketplace soon offered a vast array of dashboard software from which to choose.

Dispelling the Confusion

Like many products that hit the high-tech scene with a splash, dashboards are veiled in marketing hype. Virtually every vendor in the BI space claims to sell dashboard software, but few clarify what dashboards actually are. I'm reminded of the early years of data warehousing, when—eager to learn about this new approach to data management—I asked my IBM account manager how IBM defined the term. His response was classic and refreshingly candid: "By data warehousing we at IBM mean whatever the customer thinks it means." I realize that this wasn't IBM's official definition, which I'm sure existed somewhere in their literature, but it was my blue-suited friend's way of saying that as a salesperson, it was useful to leave the term vague and flexible. As long as a product or service remains undefined or loosely defined, it is easy to claim that your company sells it.

Those rare software vendors that have taken the time to define the term in their marketing literature start with the specific features of their products as the core of the definition, rather than a generic description. As a result, vendor definitions tend to be self-validating lists of technologies and features. For example, Dr. Gregory L. Hovis, Director of Product Deployment for Snippets Software, Inc., asserts:

Gregory L. Hovis, *"Stop Searching for Information—Monitor it with Dashboard Technology,"* DM Direct, *February 2002.*

> Able to universally connect to any XML or HTML data source, robust dashboard products intelligently gather and display data, providing business intelligence without interrupting work flow...An enterprise dashboard is characterized by a collection of intelligent agents (or gauges), each performing frequent bidirectional communication with data sources. Like a virtual staff of 24x7 analysts, each agent in the dashboard intelligently gathers, processes and presents data, generating alerts and revising actions as conditions change.

Mark Leon, "Dashboard Democracy," *Computerworld,* June 16, 2003

An article in the June 16, 2003 edition of *Computerworld* cites statistics from a study done by AMR Research, Inc., which declares that "more than half of the 135 companies... recently surveyed are implementing dashboards."

Unfortunately, the author never tells us what dashboards are. He teases us with hints, stating that dashboards and scorecards are BI tools that "have found a new home in the cubicles," having moved from where they once resided (exclusively in executive suites) under the name Executive Information Systems. He gives examples of how dashboards are being used and speaks of their benefits, but leaves it to us to piece together a sense of what they are. The closest he comes to a definition is when he quotes John Hagerty of AMR Research, Inc.: "Dashboards and scorecards are about measuring."

While conducting an extensive literature review in 2003 in search of a good working definition, I visited DataWarehousingOnline.com and clicked on the link to "Executive Dashboard" articles. In response, I received the same 18 web pages of links that I found when I separately clicked on links for "Balanced Scorecard," "Data Quality and Integration," and "Data Mining." Either the links weren't working properly, or this web portal for the data warehousing industry at the time believed that these terms all meant the same thing.

I finally decided to begin the task of devising a working definition of my own by examining every example of a dashboard I could find on the Web, in search of their common characteristics. You might find it interesting to take a similar journey. In the next few pages, you'll see screenshots of an assortment of dashboards, which were mostly found on the web sites of vendors that sell dashboard software. Take the time now to browse through these examples and see if you can discern common threads that might be woven into a useful definition.

By including these examples from the web sites of software vendors and a few other sources, I do not mean to endorse any of these dashboards or the software products used to create them as examples of good design, nor as extraordinary examples of poor design. To varying degrees they all exhibit visual design problems that I'll address in later chapters.

This dashboard from Business Objects relies primarily on graphical means to display a series of performance measures, along with a list of alerts. Notice that the title of this dashboard is "My KPIs." Key performance indicators and dashboards appear to be synonymous in the minds of most vendors. Notice the gauges as well. We'll see quite a few of them.

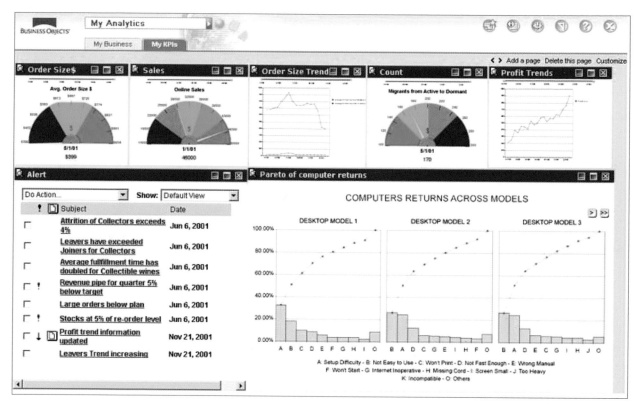

Figure 1-2

This dashboard from Oracle Corporation displays a collection of sales measures for analyzing product performance by category. All of the measures are displayed graphically. We'll find that this emphasis on graphical display media is fairly common.

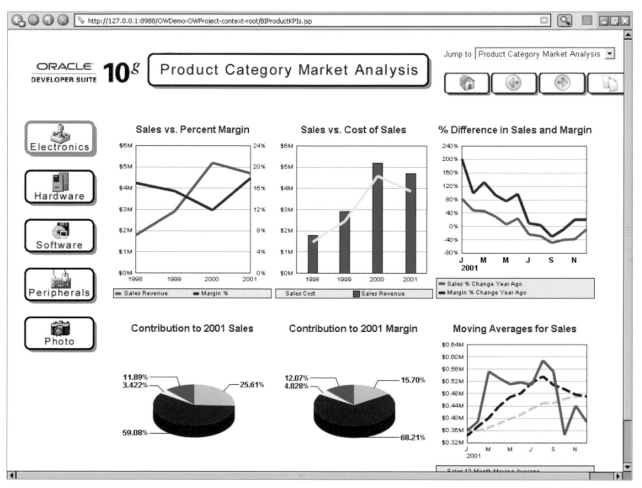

Figure 1-3

This dashboard from Informatica Corporation displays measures of revenue by sales channel along with a list of reports that can be viewed separately. The predominance of graphical display media that we observed on the previous dashboards appears on this one as well, notably in the form of meters designed to look like speedometers. The list of reports adds portal functionality, enabling this dashboard to operate as a launch pad to complementary information.

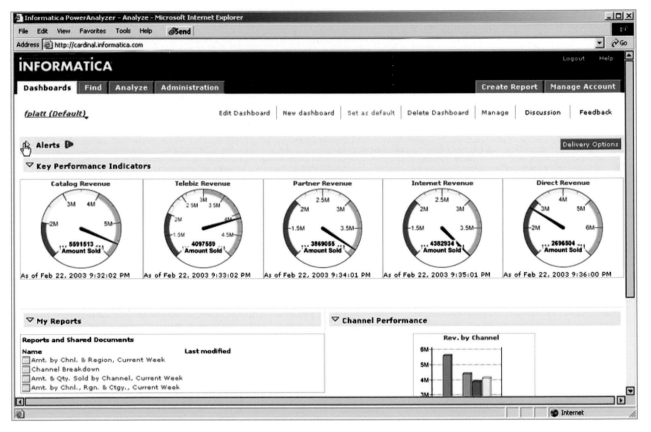

Figure 1-4

This dashboard from Principa provides an overview of a company's financial performance compared to targets for the month of March, both in tabular form and as a series of gauges. The information can be tailored by selecting different months and amounts of history. Once again, we see a strong expression of the dashboard metaphor, this time in the form of graphical devices that were designed to look like fuel gauges.

Bondi Distribution Company

Enterprise ▾

March ▾ ○ Latest month ● Year to date ○ Full year projection | Print | Target | Drivers | Cash | Home

Enterprise	As at:	Mar-01
	YTD	Target
Revenue	1,025,041	989,664
Cost of Sales	648,585	658,872
Gross Profit	376,456	330,792
Direct Expenses	12,706	9,000
Contribution Margin	363,750	321,792
Other Income (Expense)	1,374	1,500
Overheads	209,176	205,500
Net Profit before Tax	155,948	117,792
Gross Profit %	36.73%	33.42%
Average Transaction Value	133.21	121.19
Number of Transactions	7,695	8,166

Net Profit — 32.4 %
Variance 32.39%
Over target 38,156

Revenue — 3.6 %
Variance 3.57%
Over target 35,377

Gross Profit — 13.8 %
Variance 13.80%
Over target 45,664

Gross Profit % — 36.7 %
Variance 3.30%
Over target 3.30%

Other Income (Expense) — -8.4 %
Variance -8.40%
Under target (126)

Direct Expenses — 41.2 %
Variance 41.18%
Over budget 3,706

Overheads — 1.8 %
Variance 1.79%
Over budget 3,676

Figure 1-5

This dashboard from Cognos, Inc. displays a table and five graphs—one in the form of a world map—to communicate sales information. Despite the one table, there's a continued emphasis on graphical media. Notice also that a theme regarding the visual nature and need for visual appeal of dashboards is emerging in these examples.

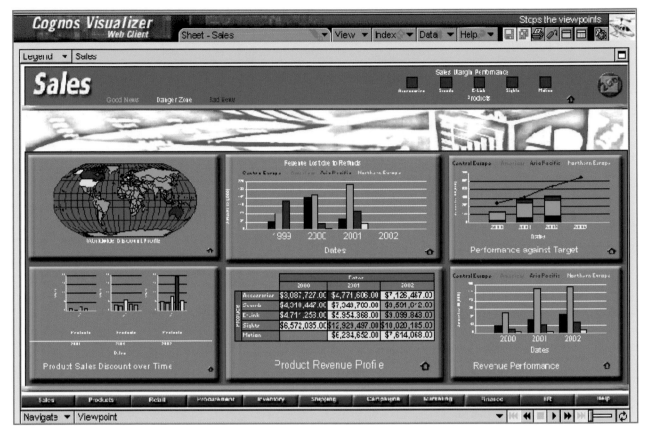

Figure 1-6

This dashboard from Hyperion Solutions Corporation displays regional sales revenue in three forms: on a map, in a bar graph, and in a table. Data can be filtered by means of three sets of radio buttons on the left. These filtering mechanisms build rudimentary analytical functionality into this dashboard. Visual decoration reinforces the theme that dashboards intentionally strive for visual appeal.

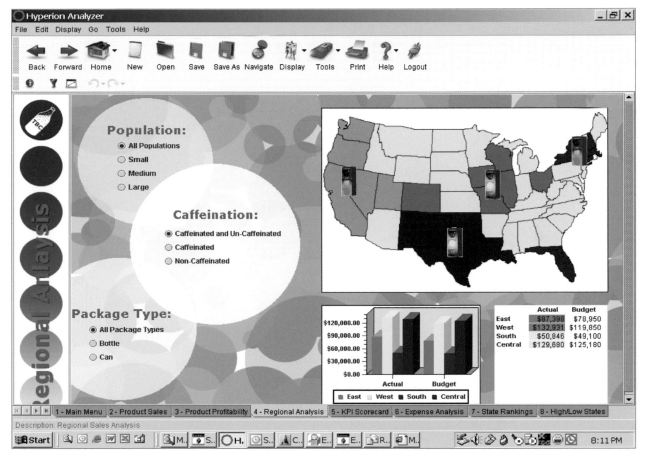

Figure 1-7

This dashboard from Corda Technologies, Inc. features flight-loading measures for an airline using four panels of graphs. Here again we see an attention to the visual appeal of the display. Notice also in the instructions at the top that an ability to interact with the graphs has been built into the dashboard, so that users can access additional information in pop-ups and drill into greater levels of detail.

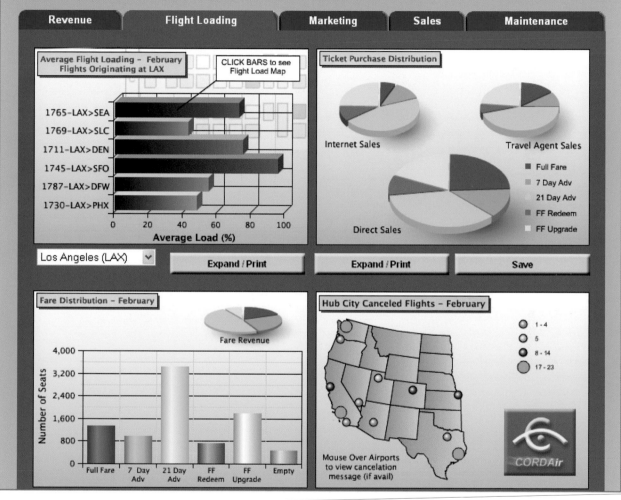

Figure 1-8

This dashboard from Visual Mining, Inc. displays various measures of a city's transit system to give the executives in charge a quick overview of the system's current and historical performance. Use of the colors green, yellow, and red to indicate good, satisfactory, and bad performance, as you can see on the three graphical displays arranged horizontally across the middle, is common on dashboards.

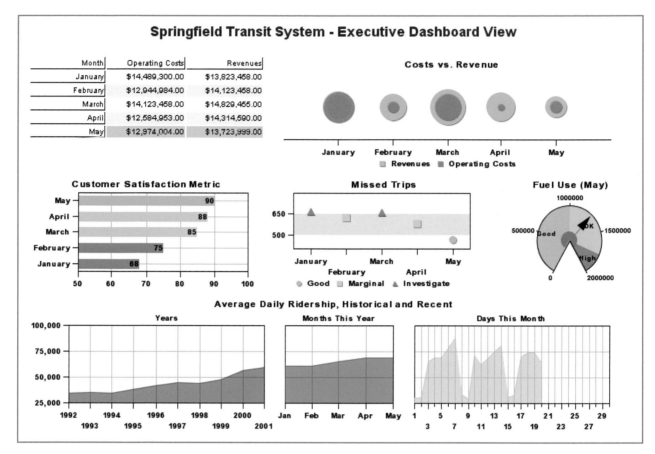

Figure 1-9

This dashboard from Infommersion, Inc. gives executives of a hotel chain the means to view multiple measures of performance, one hotel at a time. It is not unusual for dashboards to divide the full set of data into individual views, as this one does by using the listbox in the upper-left corner to enable viewers to select an individual hotel by location. The great care that we see in this example to realistically reproduce the dashboard metaphor, even down to the sheen on polished metal, is an effort that many vendors take quite seriously.

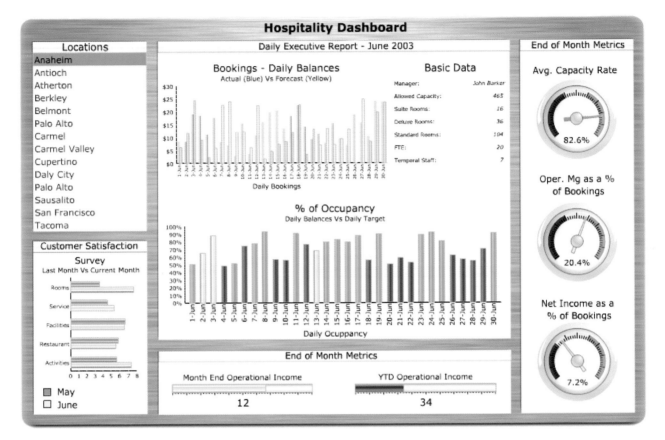

Figure 1-10

This dashboard from General Electric, called a "digital cockpit," provides a tabular summary of performance, complemented by a color-coded indicator light for each measure's status. Rather than a dashboard designed by a software vendor to exhibit its product, this is an actual working dashboard that was designed by a company to serve its own business needs. In this example, no effort was made to literally represent the dashboard (or cockpit) metaphor.

GE Business Digital Cockpit

Close Window

GE Stock: **38.7** ▲+1.0 at 16:02 ET Jan 22, 2002

Welcome, Jeffrey E-mail this Page | Print this page

| Tools | Total | Sub-business | Sub-business | Sub-business | Sub-business |

Total Performance Summary

Last Update 1/21/02 7:59:16am

Tools
- Message Center (2)
- Cockpit Map
- Cockpit Pop-up
- Download to PDA
- View Charts

Sell

Metric	Alerts ▽		Result ▽	Alert Spec ▽	Last Update ▽
QTD Sales ($MM)	2	●	$ 153.0	$ 166.0	1/21/02
QTD Average Daily Order Rate (ADOR) ($MM)	1	○	$ 16.1	$ 11.9	1/21/02
Previous Day's Orders ($MM)	0	○	$ 26.2	$ 11.9	1/21/02
QTD % e-Orders	3	●	53.0%	59.0%	1/21/02
Current Qtr Price vs Target ($/lb)	6	○	$ 1.27	$ 1.20	1/21/02

Make

Metric	Alerts ▽		Result ▽	Alert Spec ▽	Last Update ▽
Span in Days	2	○	5	6	1/18/02
Finished Good Inventory	0	○	NA	NA	1/17/02
% Make To Inventory (MTI) of Total Inventory	0	○	NA	NA	1/17/02
QTD Digitization Savings ($MM)	7	●	$ 13.2	$ 20.3	1/21/02

Buy

Metric	Alerts ▽		Result ▽	Alert Spec ▽	Last Update ▽
YTD Indirect Conversion Cost % Change	1	●	-14%	-15%	1/17/02
YTD Indirect Short Term Cost % Change	2	○	-22%	-15%	1/17/02
Realized Direct e-Auction Savings YTD ($MM)	2	○	$ 5.4	$ 1.3	1/21/02
Closed Direct e-Auctions YTD ($MM)	4	○	$ 142.0	$ 55.0	1/21/02

Figure 1-12

This dashboard is used by the Treasury Board of Canada to monitor the performance of a project. Here again we have a dashboard that was designed by an organization for its own use. This time, the dashboard metaphor makes a token appearance in the form of gauges. The traffic-light colors green, yellow, and red—here with the addition of blue for the exceptionally good status of "ahead of schedule"—are also used. Unlike some of the examples that we've seen that displayed relatively little information, this one makes the attempt to provide the comprehensive overview that would be needed to effectively monitor progress and performance.

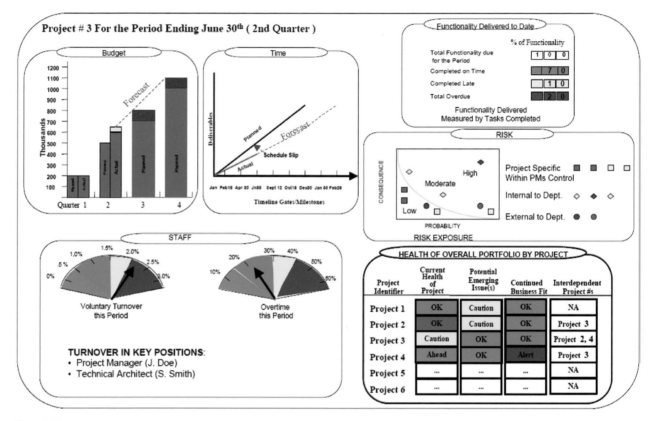

Figure 1-13

What Is a Dashboard?

As you have no doubt determined by examining these examples, there's a fair degree of diversity in the products that go by the name "dashboard." One of the few characteristics that most vendors seem to agree on is that for something to be called a dashboard it must include graphical display mechanisms such as traffic lights and a variety of gauges and meters, many similar to the fuel gauges and speedometers found in automobiles. This clearly associates BI dashboards with the familiar versions found in cars, thereby leveraging a useful metaphor—but the metaphor alone doesn't provide an adequate definition. About the only other thread that is common to these dashboard examples is that they usually attempt to provide an overview of something that's currently going on in the business.

After a great deal of research and thought, I composed a definition of my own that captures the essence of what I believe a dashboard is (clearly biased toward the characteristics of this medium that I find most useful and unique). To serve us well, this definition must clearly differentiate dashboards from other forms of data presentation, and it must emphasize those characteristics that effectively support the goal of communication. Here's my definition, which originally appeared in *Intelligent Enterprise* magazine:

Stephen Few, "Dashboard Confusion," *Intelligent Enterprise*, March 20, 2004.

> A dashboard is a visual display of the most important information needed to achieve one or more objectives; consolidated and arranged on a single screen so the information can be monitored at a glance.

Just as the dashboard of a car provides critical information needed to operate the vehicle at a glance, a BI dashboard serves a similar purpose, whether you're using it to make strategic decisions for a huge corporation, run the daily operations of a team, or perform tasks that involve no one but yourself. The means is a single-screen display, and the purpose is to efficiently monitor the information needed to achieve one's objectives.

Visual display

of

the most important information needed to achieve one or more objectives

which

fits entirely on a single computer screen

so it can be

monitored at a glance

Let's go over the salient points:

Dashboards are visual displays. The information on a dashboard is presented visually, usually as a combination of text and graphics, but with an emphasis on graphics. Dashboards are highly graphical, not because it is cute, but because graphical presentation, handled expertly, can often communicate with greater efficiency and richer meaning than text alone. How can you best present the information so that human eyes can take it in quickly and human brains can easily extract the correct and most important meanings from it? To design dashboards effectively, you must understand something about visual perception—what works, what doesn't, and why.

Dashboards display the information needed to achieve specific objectives. To achieve even a single objective often requires access to a collection of information that is not otherwise related, often coming from diverse sources related to various business functions. It isn't a specific type of information, but information of whatever type that is needed to do a job. It isn't just information that is needed by executives or even by managers; it can be information that is needed by anyone who has objectives to meet. The required information can be and often is a set of KPIs, but not necessarily, for other types of information might also be needed to do one's job.

A dashboard fits on a single computer screen. The information must fit on a single screen, entirely available within the viewer's eye span so it can all be seen at once, at a glance. If you must scroll around to see all the information, it has transgressed the boundaries of a dashboard. If you must shift from screen to screen to see it all, you've made use of multiple dashboards. The object is to have the most important information readily and effortlessly available so you can quickly absorb what you need to know.

Must the information be displayed in a web browser? That might be the best medium for most dashboards today, but it isn't the only acceptable medium, and it might not be the best medium 10 years from now. Must the information be constantly refreshed in real time? Only if the objectives that it serves require real-time information. If you are monitoring air traffic using a dashboard, you must immediately be informed when

something is wrong. On the other hand, if you are making strategic decisions about how to boost sales, a snapshot of information as of last night, or perhaps even the end of last month, should work fine.

Dashboards are used to monitor information at a glance. Despite the fact that information about almost anything can be appropriately displayed in a dashboard, there is at least one characteristic that describes almost all the information found in dashboards: it is abbreviated in the form of summaries or exceptions. This is because you cannot monitor at a glance all the details needed to achieve your objectives. A dashboard must be able to quickly point out that something deserves your attention and might require action. It needn't provide all the details necessary to take action, but if it doesn't, it ought to make it as easy and seamless as possible to get to that information. Getting there might involve shifting to a different display beyond the dashboard, using navigational methods such as drilling down. The dashboard does its primary job if it tells you with no more than a glance that you should act. It serves you superbly if it directly opens the door to any additional information that you need to take that action.

That's the essence of the dashboard. Now let's add to this definition a couple more supporting attributes that help dashboards do their job effectively:

Dashboards have small, concise, clear, and intuitive display mechanisms. Display mechanisms that clearly state their message without taking up much space are required, so that the entire collection of information will fit into the limited real estate of a single screen. If something that looks like a fuel gauge, traffic signal, or thermometer fits this requirement best for a particular piece of information, that's what you should use, but if something else works better, you should use that instead. Insisting on sexy displays similar to those found in a car when other mechanisms would work better is counterproductive.

Dashboards are customized. The information on a dashboard must be tailored specifically to the requirements of a given person, group, or function; otherwise, it won't serve its purpose.

A dashboard is a type of display, a form of presentation, not a specific type of information or technology. Keep this distinction clear, and you will be freed to focus on what really matters: designing dashboards to communicate.

A Timely Opportunity

Several circumstances have recently combined to create a timely opportunity for dashboards to add value to the workplace, including technologies such as high-resolution graphics, emphasis on performance management and metrics, and a growing recognition of visual perception as a powerful channel for information acquisition and comprehension. Dashboards offer a unique solution to the problem of information overload—not a complete solution by any means, but one that helps a lot. As Dr. Hovis wrote in that same article in *DM Direct*:

> The real value of dashboard products lies in their ability to replace hunt-and-peck data-gathering techniques with a tireless, adaptable, information-flow mechanism. Dashboards transform data repositories into consumable information.

Gregory L. Hovis, "Stop Searching for Information – Monitor it with Dashboard Technology," DM Direct, February 2002

Dashboards aren't all that different from some of the other means of presenting information, but when properly designed the single-screen display of integrated and finely tuned data can deliver insight in an especially powerful way.

> Dashboards and visualization are cognitive tools that improve your "span of control" over a lot of business data. These tools help people visually identify trends, patterns and anomalies, reason about what they see and help guide them toward effective decisions. As such, these tools need to leverage people's visual capabilities. With the prevalence of scorecards, dashboards and other visualization tools now widely available for business users to review their data, the issue of visual information design is more important than ever.

Richard Brath and Michael Peters, "Dashboard Design: Why Design is Important," *DM Direct*, October 2004

The final sentiment that Brath and Peters expressed in this excerpt from their article underscores the purpose of this book. As data visualization becomes increasingly common as a means of business communication, it is imperative that expertise in data visualization be acquired. This expertise must be grounded in an understanding of visual perception, and of how this understanding can be effectively applied to the visual display of data—what works, what doesn't, and why. These skills are rarely found in the business world, not because they are difficult to learn, but because the need to learn them is seldom recognized. This is true in general, and especially with regard to dashboards. The challenge of presenting a large assortment of data on a single screen in a way that produces immediate insight is by no means trivial. Buckle up; you're in for a fun ride.

2

VARIATIONS IN DASHBOARD USES AND DATA

Dashboards can be used to monitor many types of data and to support almost any set of objectives a business deems important. There are many ways to categorize dashboards into various types. The way that relates most directly to a dashboard's visual design involves the role it plays, whether strategic, analytical, or operational. The design characteristics of the dashboard can be tailored to effectively support the needs of each of these roles. While certain differences such as these will affect design, there are also many commonalities that span all dashboards and invite a standard set of design practices.

Dashboards are used to support a broad spectrum of information needs, spanning the entire range of business efforts that might benefit from an immediate overview of what's going on. Dashboards can be tailored to specific purposes, and a single individual might benefit from multiple dashboards, each supporting a different aspect of that person's work. The various data and purposes that dashboards can be used to support are worth distinguishing, for they sometimes demand differences in visual design and functionality.

Categorizing Dashboards

Dashboards can be categorized in several ways. No matter how limited and flawed the effort, doing so is useful because it helps us to examine the benefits and many uses of the medium. I'm one of those people who enjoys the process of classifying things, breaking them up into groups. It's an intellectual exercise that forces me to dig beneath the surface. I don't, however, assign undue worth to any one way of categorizing something, and I certainly don't ever want to give in to the arrogance of claiming that mine is the only way.

Taxonomies—a scientific term for systems of classification—are always based on one or more variables (that is, categories consisting of multiple potential values). For instance, based on the variable "platform," a dashboard taxonomy could consist of those that run in client/server mode and those that run in web browsers. The following table lists several variables that can be used to structure dashboard taxonomies, along with potential values for each. This list certainly isn't comprehensive; these are simply my attempts to express the variety and explore the potential of the dashboard medium.

Dashboards for operational purposes

When dashboards are used to monitor operations, they must be designed differently from those that support strategic decision making or data analysis. The characteristic of operations that uniquely influences the design of dashboards most is their dynamic and immediate nature. When you monitor operations, you must maintain awareness of activities and events that are constantly changing and might require attention and response at a moment's notice. If the robotic arm on the manufacturing assembly line that attaches the car door to the chassis runs out of bolts, you can't wait until the next day to become aware of the problem and take action. Likewise, if traffic on your web site suddenly drops to half its normal level, you want to be notified immediately.

As with strategic dashboards, the display media on operational dashboards must be very simple. In the stressful event of an emergency that requires an immediate response, the meaning of the situation and the appropriate responses must be extremely clear and simple, or mistakes will be made. In contrast to strategic dashboards, operational dashboards must have the means to grab your attention immediately if an operation falls outside the acceptable threshold of performance. Also, the information that appears on operational dashboards is often more specific, providing a deeper level of detail. If a critical shipment is at risk of missing its deadline, a high-level statistic won't do; you need to know the order number, who's handling it, and where it is in the warehouse. Details like these might appear automatically on an operational dashboard, or they might be accessed by drilling down on or hovering the mouse over higher-level data, so interactivity is often useful.

The ways that dashboard design must take different forms in response to different roles are clearly worth your attention. We'll examine some of these differences in more detail in Chapter 8, *Putting It All Together*, when we review several examples of what works and what doesn't for various purposes.

Typical Dashboard Data

Dashboards are useful for all kinds of work. Whether you're a meteorologist monitoring the weather, an intelligence analyst monitoring potential terrorist chatter, a CEO monitoring the health and opportunities of a multi-billion dollar corporation, or a financial analyst monitoring the stock market, a well-designed dashboard could serve you well.

The Common Thread in Dashboard Diversity

Despite these diverse applications, in almost all cases dashboards primarily display *quantitative measures of what's currently going on*. This type of data is common across almost all dashboards because they are used to monitor the critical information needed to do a job or meet one or more particular objectives, and most (but not all, as we'll see later) of the information that does this best is quantitative.

The following table lists several measures of "what's currently going on" that are typical in business.

Category	Measures
Sales	Bookings Billings Sales pipeline (anticipated sales) Number of orders Order amounts Selling prices
Marketing	Market share Campaign success Customer demographics
Finance	Revenues Expenses Profits
Technical Support	Number of support calls Resolved cases Customer satisfaction Call durations
Fulfillment	Number of days to ship Backlog Inventory levels
Manufacturing	Number of units manufactured Manufacturing times Number of defects
Human Resources	Employee satisfaction Employee turnover Count of open positions Count of late performance reviews
Information Technology	Network downtime System usage Fixed application bugs
Web Services	Number of visitors Number of page hits Visit durations

particular measures without altering the overall design of the dashboard. Evaluative indicators need not be limited to binary distinctions between good and bad, but if they exceed the limit of more than a few distinct states (for example, very bad, bad, acceptable, good, and very good), they run the risk of becoming too complex for efficient perception.

Non-Quantitative Dashboard Data

Many people think of dashboards and KPIs as nearly synonymous. It is certainly true that dashboards are a powerful medium for presenting KPIs, but not all quantitative information that might be useful on a dashboard belongs to the list of defined KPIs. In fact, not all information that is useful on dashboards is even quantitative—the critical information needed to do a job cannot always be expressed numerically. Although most information that typically finds its way onto a dashboard *is* quantitative, some types of non-quantitative data, such as simple lists, are fairly common as well. Here are a few examples:

- Top 10 customers
- Issues that need to be investigated
- Tasks that need to be completed
- People who need to be contacted

Another type of non-quantitative data occasionally found on dashboards relates to schedules, including tasks, due dates, the people responsible, and so on. This is common when the job that the dashboard supports involves the management of projects or processes.

A rarer type involves the display of entities and their relationships. Entities can be steps or stages in a process, people or organizations that interact with one another, or events that affect one another, to name a few common examples. This type of display usually encodes entities as circles or rectangles and relationships as lines, often with arrows at one or both ends to indicate direction or influence. It is often useful to integrate quantitative information that is associated with the entities and relationships, such as the amount of time that passed between events in a process (for example, by associating a number with the line that links the events or by having the length of the line itself encode the duration) or the sizes of business entities (perhaps expressed in revenues or number of employees).

Now that you know a bit about how and why dashboards are used, it's time to take a closer look at some design principles. In the next chapter, we'll delve into some of the mistakes that are commonly made in dashboard design.

3

THIRTEEN COMMON MISTAKES
IN DASHBOARD DESIGN

Preoccupation with superficial and functionally distracting visual characteristics of dashboards has led to a rash of visual design problems that undermine their usefulness. Thirteen visual design problems are frequently found in dashboards, including in the examples featured as exemplary by software vendors.

Exceeding the boundaries of a single screen

Supplying inadequate context for the data

Displaying excessive detail or precision

Choosing a deficient measure

Choosing inappropriate display media

Introducing meaningless variety

Using poorly designed display media

Encoding quantitative data inaccurately

Arranging the data poorly

Highlighting important data ineffectively or not at all

Cluttering the display with useless decoration

Misusing or overusing color

Designing an unattractive visual display

The fundamental challenge of dashboard design is the need to squeeze a great deal of information into a small amount of space, resulting in a display that is easily and immediately understandable. If this doesn't sound challenging, either you are an expert designer with extensive dashboard experience, or you are basking in the glow of naiveté. Attempt the task, and you will find that dashboards pose a unique data visualization challenge. And don't assume that you can look to your software vendor for help—if they have the necessary design talent, they're doing a great job of hiding it.

Sadly, it is easy to find many examples of the mistakes you should avoid by looking no further than the web sites of the software vendors themselves. Let's use some of these examples to examine design that doesn't work and learn why it doesn't.

In almost every case, I've chosen to use actual examples from vendor web sites to illustrate dashboard design mistakes. In doing so, I am not saying that the software that produced the example is bad—I'm not commenting on the quality of the software one way or another. What I am saying is that the design practice is bad. This results primarily from vendors' lack of expertise in or inattention to visual design. These vendors should know better, but they've chosen to focus their energies on other aspects of their products, often highlighting glitzy visual features that actually undermine effective communication. I hope that seeing their work used to illustrate poor dashboard design will serve as a wake-up call to start paying attention to the features that really matter.

Exceeding the Boundaries of a Single Screen

My insistence that a dashboard should confine its display to a single screen, with no need for scrolling or switching between multiple screens, might seem arbitrary and a bit finicky, but it is based on solid and practical rationale. After studying data visualization for a while, including visual perception, one discovers that something powerful happens when things are seen together, all within eye span. Likewise, something critical is lost when you lose sight of some data by scrolling or switching to another screen to see other data. Part of the problem is that we can hold only a few chunks of information at a time in short-term memory. Relying on the mind's eye to remember information that is no longer visible is a rocky venture.

One of the great benefits of a dashboard as a medium of communication is the simultaneity of vision that it offers: the ability to see everything that you need at once. This enables comparisons that lead to insights—those "Aha!" experiences that might not occur in any other way. Clearly, exceeding the boundaries of a single screen negates this benefit. Let's examine the two versions of this problem—fragmenting data into separate screens and requiring scrolling—independently.

Fragmenting Data into Separate Screens

Information that appears on dashboards is often fragmented in one of two ways:

- Separated into discrete screens to which one must navigate
- Separated into different instances of a single screen that are accessed through some form of interaction

Enabling users to navigate to discrete screens or different instances of a single screen to access additional information is not, in general, a bad practice. Allowing navigation to further detail or to a different set of information that achieves its purpose best by standing alone can be a powerful dashboard feature. However, when all the information should be seen at the same time to gain the desired insights, that fragmentation undermines the unique advantages of a dashboard. Fragmenting data that should be seen together is a mistake.

Let's look at an example. The dashboard in Figure 3-1 fragments the data that executives need into 10 separate dashboards. This would be fine if the executives wouldn't benefit from seeing these various measures together, but that is hardly the case.

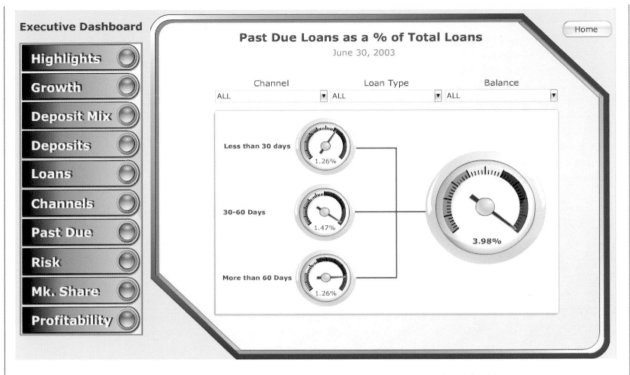

Figure 3-1. This dashboard fragments the data in a way that undermines the viewer's ability to see meaningful relationships.

In this example, a banking executive is forced to examine the performance of the following aspects of the business separately:

- Highlights
- Deposits
- Past due loans
- Profitability
- Growth
- Loans
- Risk
- Deposit mix
- Channels
- Market share

Each of these screens presents a separate, high-level snapshot of a single set of measures that ought to be integrated into a single screen. Despite what you might assume about the available screen labeled "Highlights," it does not provide a consolidated visual overview of the data but consists primarily of a text table that contains several of the measures. A banking executive needs to see these measures together in a way that enables comparisons to understand how they relate to and influence one another.

Splitting the big picture into a series of separate small pictures is a mistake whenever seeing the big picture is worthwhile.

A similar example, from the same software vendor, is shown in Figure 3-2. This time the picture of daily sales has been split into a separate dashboard for each of 20 products. If the intention is to serve the needs of product managers who are each exclusively interested in a single product and never want to compare sales of that product to others, this design doesn't fragment the data in a harmful way. If, however, any benefit can be gained by viewing the sales of multiple products together, which is almost surely the case, this design fails.

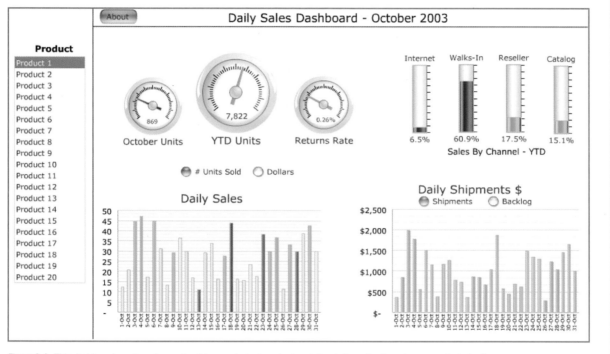

Figure 3-2. This dashboard requires viewers to click on a desired product and view information for only one product at a time.

Requiring Scrolling

The dashboard in Figure 3-3 illustrates the problem that's created when scrolling is required to see all the data. Not only are we left wondering what lies below the bottom of the screen in the dashboard as a whole, but we're also given immediate visual access only to the first of many metrics that appear in the scrollable box at the top right, beginning with "No. Transactions." We'd be better off reading a printed report extending across multiple pages, because at least then we could lay out all of the pages at once for simultaneous viewing. People commonly assume that anything that lies beyond their immediate field of vision and requires scrolling to see

is of less importance than what's immediately visible. Many viewers won't bother to look at what lies off the screen, and those who take the time will likely resent the effort.

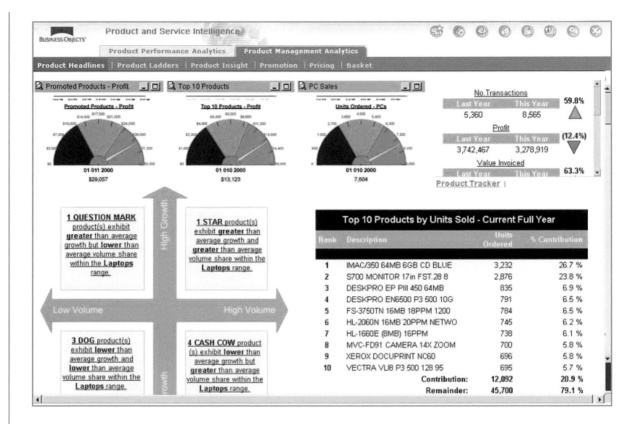

Figure 3-3. This dashboard demonstrates the effectiveness that is sacrificed when scrolling is required to see all the information.

Supplying Inadequate Context for the Data

Measures of what's currently going on in the business rarely do well as a solo act; they need a good supporting cast to succeed. For example, to state that quarter-to-date sales total $736,502 without any context means little. Compared to what? Is this good or bad? How good or bad? Are we on track? Are we doing better than we have in the past, or worse than we've forecasted? Supplying the right context for key measures makes the difference between numbers that just sit there on the screen and those that enlighten and inspire action.

The gauges in Figure 3-4 could easily have incorporated useful context, but they fall short of their potential. For instance, the center gauge tells us only that 7,822 units have sold this year to date, and that this number is good (indicated by the green arrow). A quantitative scale on a graph, such

as the radial scales of tick marks on these gauges, is meant to provide an approximation of the measure, but it can only do so if the scale is labeled with numbers, which these gauges lack. If the numbers had been present, the positions of the arrows might have been meaningful, but here the presence of the tick marks along a radial axis suggests useful information that hasn't actually been included.

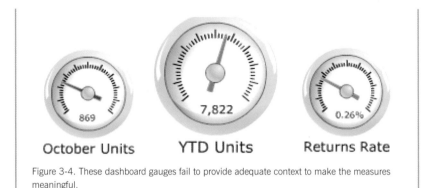

October Units YTD Units Returns Rate

Figure 3-4. These dashboard gauges fail to provide adequate context to make the measures meaningful.

These gauges use up a great deal of space to tell us nothing whatsoever. The same information could have been communicated simply as text in much less space, without any loss of meaning:

YTD Units	7,822
October Units	869
Returns Rate	0.26%

Another failure of these gauges is that they tease us by coloring the arrows to indicate good or bad performance, without telling us *how* good or bad it is. They could easily have done this by labeling the quantitative scales and visually encoding sections along the scales as good or bad, rather than just encoding the arrows in this manner. Had this been done, we would be able to see at a glance how good or bad a measure is by how far the arrow points into the good or bad ranges.

The gauge that appears in Figure 3-5 does a better job of incorporating context in the form of meaningful comparisons. Here, the potential of the graphical display is more fully realized. The gauge measures the average duration of phone calls and is part of a larger dashboard of call-center data.

Supplying context for measures need not always involve a choice of the single best comparison—rather, several contexts may be given. For instance, quarter-to-date sales of $736,502 might benefit from comparisons to the budget target of $1,000,000; sales on this day last year of $856,923; and a time-series of sales figures for the last six quarters. Such a display would provide much richer insight than a simple display of the

current sales figure, with or without an indication of whether it's "good" or "bad." You must be careful, however, when incorporating rich context such as this to do so in a way that doesn't force the viewer to get bogged down in reading the details to get the basic message. It is useful to provide a visually prominent display of the primary information and to subdue the supporting context somewhat, so that it doesn't get in the way when the dashboard is being quickly scanned for key points.

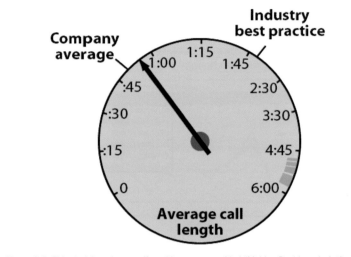

Figure 3-5. This dashboard gauge (found in a paper entitled "Making Dashboards Actionable," written by Laurie M. Orlov and published in December 2003 by Forrester Research, Inc.) does a better job than those in Figure 3-4 of using a gauge effectively.

I believe that the circular shape used by gauges like this one wastes valuable space on a dashboard, as I'll explain in Chapter 6, *Effective Dashboard Display Media*. Nevertheless, I commend this gauge for displaying richer information than most.

The amount of context that ought to be incorporated to enrich the measures on a dashboard depends on its purpose and the needs of its viewers. More is not always better, but when more provides real value, it ought to be included in a way that supports both a quick overview without distraction as well as contextual information for richer understanding.

Displaying Excessive Detail or Precision

Dashboards almost always require fairly high-level information to support the viewer's need for a quick overview. Too much detail, or measures that are expressed too precisely (for example, $3,848,305.93 rather than $3,848,305, or perhaps even $3.8M), just slow viewers down without providing them any benefit. In a way, this problem is the opposite extreme of the one we examined in the previous section—too much information rather than too little.

The dashboard in Figure 3-6 illustrates this type of excess. Examine the two sections that I've enclosed in red rectangles. The lower-right section

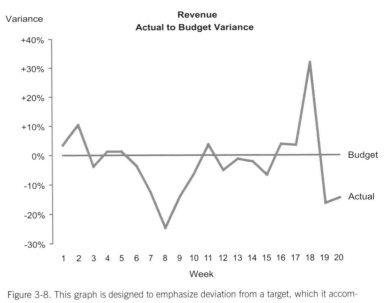

Figure 3-8. This graph is designed to emphasize deviation from a target, which it accomplishes in part by expressing the difference between budgeted and actual revenues using percentages.

Choosing Inappropriate Display Media

Choosing inappropriate display media is one of the most common design mistakes made, not just in dashboards, but in all forms of quantitative data presentation. For instance, using a graph when a table of numbers would work better, and vice versa, is a frequent mistake. Allow me to illustrate using several examples beginning with the pie chart in Figure 3-9.

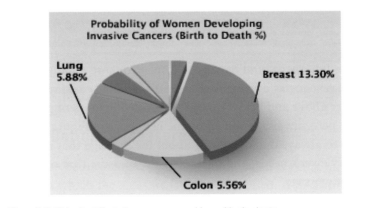

Figure 3-9. This chart illustrates a common problem with pie charts.

This pie chart is part of a dashboard that displays breast cancer statistics. Look at it for a moment and see if anything seems odd.

Pie charts are designed specifically to present parts of a whole, and the whole should always add up to 100%. Here, the slice labeled "Breast 13.30%" looks like it represents around 40% of the pie—a far cry from 13.3%. Despite the meaning that a pie chart suggests, these slices are not parts of a whole; they represent the probability that a woman will develop a particular form of cancer (breast, lung, colon, and six types that aren't labeled). This misuse of a pie chart invites confusion.

The truth is, I never recommend the use of pie charts. The only thing they have going for them is the fact that everybody immediately knows when they see a pie chart that they are seeing parts of a whole (or ought to be). Beyond that, pie charts don't display quantitative data very effectively. As you'll see in Chapter 4, *Tapping into the Power of Visual Perception*, humans can't compare two-dimensional areas or angles very accurately— and these are the two means that pie charts use to encode quantitative data. Bar graphs are a much better way to display this information.

The pie chart in Figure 3-10 shows that even when correctly used to present parts of a whole, these graphs don't work very well. Without the value labels, you would only be able to discern that opportunities rated as "Fair" represent the largest group, those rated as "Field Sales: 2-Very High" represent a miniscule group, and the other ratings groups are roughly equal in size.

Refer to my book *Show Me the Numbers: Designing Tables and Graphs to Enlighten* (Oakland, CA: Analytics Press, 2004) for a thorough treatment of the types of graphs that work best for the most common quantitative messages communicated in business.

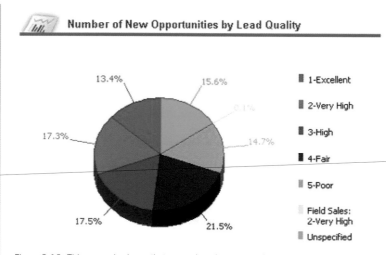

Figure 3-10. This example shows that even when they are used correctly to present parts of a whole, pie charts are difficult to interpret accurately.

The lack of labeled axes in this graph limits its meaning, but the choice of a radar graph to display this information in the first place is an even more fundamental error. Once again, a simple bar graph like the one in Figure 3-15 would communicate this data much more effectively. Radar graphs are rarely appropriate media for displaying business data. Their circular shape obscures data that would be quite clear in a linear display such as a bar graph.

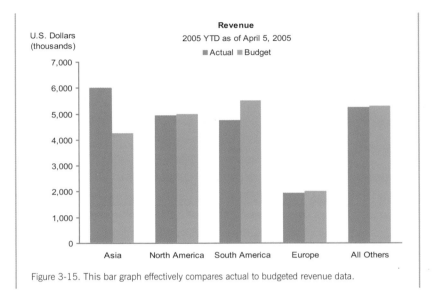

Figure 3-15. This bar graph effectively compares actual to budgeted revenue data.

The last example that I'll use to illustrate my point about choosing inappropriate means of display appears in Figure 3-16.

Figure 3-16. This display uselessly encodes quantitative values on a map of the United States.

There are times when it is very useful to arrange data spatially, such as in the form of a map or the floor plan of a building, but this isn't one of them. We don't derive any insight by laying out revenue information—in this case, whether revenues are good (green light), mediocre (yellow light), or poor (red light), in the geographical regions South (brown), Central (orange), West (tan), and East (blue)—on a map.

If the graphical display were presenting meaningful geographical relationships—say, for shipments of wine from California, to indicate where special taxes must be paid whenever deliveries cross state lines—perhaps a geographical display would provide some insight. With this simple set of four regions with no particular factors attached to geographical location, however, the use of a map simply takes up a lot of space to say no more than we find in the table that appears on this same dashboard, which is shown in Figure 3-17.

	Actual	Budget
East	$87,398	$78,950
West	$132,931	$119,850
South	$50,846	$49,100
Central	$129,680	$125,180

Figure 3-17. This table, from the same dashboard, provides a more appropriate display of the regional revenue data that appears in Figure 3-16.

Introducing Meaningless Variety

The mistake of introducing meaningless variety into a dashboard design is closely tied to the one we just examined. I've found that people often hesitate to use the same type of display medium multiple times on a dashboard, out of what I assume is a sense that viewers will be bored by the sameness. Variety might be the spice of life, but if it is introduced on a dashboard for its own sake, the display suffers. You should always select the means of display that works best, even if that results in a dashboard that is filled with nothing but multiple instances of the same type of graph. If you are giving viewers the information that they desperately need to do their jobs, the data won't bore them just because it's all displayed in the same way. They will definitely get aggravated, however, if forced to work harder than necessary to get the information they need due to arbitrary variety in the display media. In fact, wherever appropriate, consistency in the means of display allows viewers to use the same perceptual strategy for interpreting the data, which saves time and energy.

Figure 3-18 illustrates variety gone amok. This visual jumble requires a shift in perceptual strategy for each display item on the dashboard, which means extra time and effort on the user's part.

Figure 3-18. This dashboard exhibits an unnecessary variety of display media.

Using Poorly Designed Display Media

It isn't enough to choose the right medium to display the data and its message—you also must design the components of that medium to communicate clearly and efficiently, without distraction. Most graphs used in business today are poorly designed. The reason is simple: almost no one has been trained in the fundamental principles and practices of effective graph design. This content is thoroughly covered in my book *Show Me the Numbers: Designing Tables and Graphs to Enlighten*, so I won't repeat myself here. Instead, I'll simply illustrate the problem with a few examples.

In addition to the fact that a bar graph would have been a better choice to display this data (the division of revenue between six sales), Figure 3-19 exhibits several design problems. Look at it for a moment and see if you can identify aspects of its design that inhibit quick and easy interpretation.

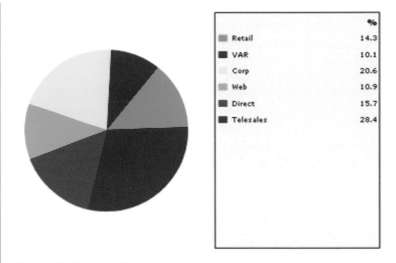

Figure 3-19. This pie chart illustrates several design problems.

Here are the primary problems that I see:

A legend was used to label and assign values to the slices of the pie. This forces our eyes to bounce back and forth between the graph and the legend to glean meaning, which is a waste of time and effort when the slices could have been labeled directly.

The order of the slices and the corresponding labels appears random. Ordering them by size would have provided useful information that could have been assimilated instantly.

The bright colors of the pie slices produce sensory overkill. Bright colors ought to be reserved for specific data that should stand out from the rest.

The pie chart in Figure 3-20 also illustrates a problem with color choice.

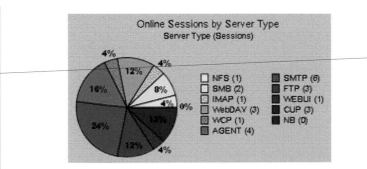

Figure 3-20. This pie chart uses of colors for the slices that are too much alike to be clearly distinguished.

In this case, the 11 colors that were chosen are too similar. It is difficult to determine which of the hues along the yellow through orange to red spectrum in the legend corresponds to each slice of the pie. This kind of eye-straining exercise is deadly, especially on a dashboard.

Another example of an ineffective display medium is shown in Figure 3-21. These meters are an attempt to be true to the metaphor of a car dashboard. Notice that the numbers look just like they would on an odometer: they lack the commas normally used to delineate every set of three digits to help us distinguish thousands from millions, and so on. In a misguided effort to make these meters look realistic, their developers made the numbers harder to read—engineers designed these meters, not business people. Notice also that numbers along the quantitative scale are positioned inside rather than outside the axis, which will cause them to be obscured by the needle when it points directly to them, and that the positioning of the text at the bottom of each meter (for example, "4382934 Amount Sold" on the "Internet Revenue" meter) obstructs the needle for measures near the bottom or top of the scale.

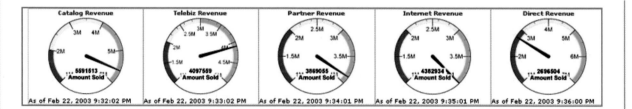

Figure 3-21. These dashboard meters have definitely taken the dashboard metaphor too far.

In the last section, I spoke of bar graphs as a preferable alternative to certain other display media. However, while bar graphs can do an excellent job of displaying quantitative data, they can be misused as well. Examine the graph in Figure 3-22, and take a moment to list any problems with its design that you see. Write down your observations below before reading on, if you'd like.

Figure 3-22. This bar graph, found on a dashboard, exhibits several design problems.

You might have noticed that the grid lines on the graph (not to mention the background pattern of colored rectangles) do nothing but distract from the data. Grid lines such as these, especially when visually prominent, make it more difficult to see the shape of the data. Perhaps you also noticed that the 3-D effect of the graph not only added no value, but also made the values encoded by the bars harder to interpret. Anything else? Well, this graph illustrates a common problem with color. Why is each of the bars a different color? The colors aren't being used to identify the bars, as each one has a label to its left. Differences in the color of data-encoding objects should always be meaningful; otherwise, they needlessly grab our attention and cause us to search for meaning that isn't there.

The distinct colors of the bars in Figure 3-23 do, thankfully, carry meaning, but here the colors are distractingly bright and the 3-D effect makes them hard to read.

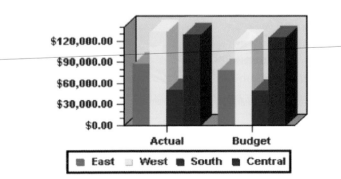

Figure 3-23. This bar graph, found on a dashboard, was poorly designed in a number of ways.

Cluttering the Display with Useless Decoration

Another common problem on the dashboards that I find on vendor web sites is the abundance of useless decoration. They either hope that we will be drawn in by the artistry or assume that the decorative flourishes are necessary to entertain us. I assure you, however, that even people who enjoy the decoration upon first sight will grow weary of it in a few days.

The makers of the dashboard in Figure 3-28 did an exceptional job of making it look like an electronic control panel. If the purpose were to train people in the use of some real equipment by means of a simulation, this would be great, but that isn't the purpose of a dashboard. The graphics dedicated to this end are pure decoration, visual content that the viewer must process to get to the data.

Figure 3-28. This dashboard is trying to look like something that it is not, resulting in useless and distracting decoration.

I suspect that the dashboard in Figure 3-29 looked too plain to its designer, so she decided to make it look like a page in a spiral-bound book—cute, but a distracting waste of space.

Figure 3-29. This dashboard is another example of useless decoration—the designer tried to make the dashboard look like a page in a spiral-bound notebook.

Likewise, I'd guess that the designer of the dashboard in Figure 3-30—after creating a map, a bar graph, and a table that all display the same data—decided that he had to fill up the remaining space, so he went wild with an explosion of blue and gray circles. Blank space is better than meaningless decoration. Can you imagine yourself looking at this every day?

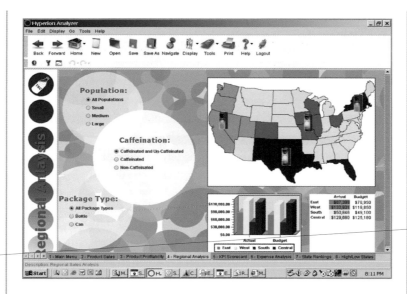

Figure 3-30. This dashboard is a vivid example of distracting ornamentation.

The last example, Figure 3-31, includes several elements of decoration that ought to be eliminated. To begin with, a visually ornate logo and title use

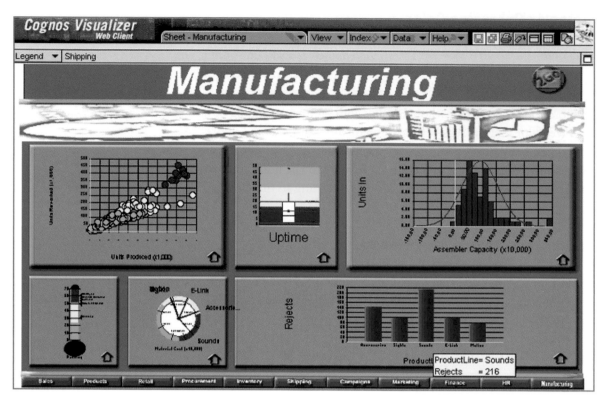

Figure 3-32. This is an example of a rather unattractive dashboard.

You don't need to be a graphic artist to design an attractive dashboard, but you do need to understand a few basic principles about visual perception. We'll examine these in the next chapter.

4

TAPPING INTO THE POWER
OF VISUAL PERCEPTION

Vision is by far our most powerful sense. Seeing and thinking are intimately connected. To display data effectively, we must understand a bit about visual perception, gleaning from the available body of scientific research those findings that can be applied directly to dashboard design: what works, what doesn't, and why.

It isn't accidental that when we begin to understand something we say, "I see." Not "I hear" or "I smell," but "I see." Vision dominates our sensory landscape. As a sensophile, I cherish the rich abundance of sounds, smells, tastes, and textures that inhabit our world, but none of these provides the rich volume, bandwidth, and nuance of information that I perceive through vision. Approximately 70% of the sense receptors in our bodies are dedicated to vision, and I suspect that there is a strong correlation between the extensive brainpower and dominance of visual perception that have co-evolved in our species. How we see is closely tied to how we think.

I've learned about visual perception from many sources, but one stands out above the others in its application to information design: the book *Information Visualization: Perception for Design* by Colin Ware. Dr. Ware expresses the importance of studying visual perception beautifully:

> Why should we be interested in visualization? Because the human visual system is a pattern seeker of enormous power and subtlety. The eye and the visual cortex of the brain form a massively parallel processor that provides the highest-bandwidth channel into human cognitive centers. At higher levels of processing, perception and cognition are closely interrelated... However, the visual system has its own rules. We can easily see patterns presented in certain ways, but if they are presented in other ways, they become invisible... The more general point is that when data is presented in certain ways, the patterns can be readily perceived. If we can understand how perception works, our knowledge can be translated into rules for displaying information. Following perception-based rules, we can present our data in such a way that the important and informative patterns stand out. If we disobey the rules, our data will be incomprehensible or misleading.

Colin Ware, *Information Visualization: Perception for Design, Second Edition* (San Francisco: Morgan Kauffman, 2004), xxi.

We'll concentrate our look at visual perception on the following areas:

- The limits of short-term visual memory
- Visual encoding for rapid perception
- Gestalt principles of visual perception

Each of these topics can be applied directly to the design of dashboards.

because italics are harder to read than normal vertically oriented text. However, it is sometimes useful in a pinch.

In dashboard design, the attribute of *line length* is most useful for encoding quantitative values as bars in a bar graph. *Line width*, on the other hand, can be useful for highlighting purposes. You can think of line width as the thickness or stroke weight of a line. When lines are used to underline content or, in the form of boxes, to form borders around content, you can draw more attention to that content by increasing the thickness of the lines.

The relative *sizes* of objects that appear on a dashboard can be used to visually rank their importance. For instance, larger titles for sections of content, or larger tables, graphs, or icons, can be used to declare the greater importance of the associated data. Simple *shapes* can be used in graphs to differentiate data sets and, in the form of icons, to assign distinct meanings, such as different types of alerts. *Added marks* are most useful on dashboards in the form of simple icons that appear next to data that need attention. Any simple mark (such as a circle, a square, an asterisk, or an X), when placed next to information only when it must be highlighted, works as a simple means of drawing attention. Last on the list of form attributes is *enclosure*, which is a powerful means of grouping sections of data or, when used sparingly, highlighting content as important. To create the visual effect of enclosure, you can use either a border or a fill color behind the content.

Attributes of Position

The preattentive attribute *2-D position* is the primary means that we use to encode quantitative data in graphs (for example, the position of data points in relation to a quantitative scale). This isn't arbitrary. Of all the preattentive attributes, differences in 2-D position are the easiest and most accurate to perceive.

Attributes of Motion

As I type these words, I am aware of my cursor flickering on and off on the screen. Flicker was chosen as the means to help us locate the cursor because it is a powerful attention-getter. Evolution has equipped us with a heightened sensitivity to something that suddenly appears within our field of vision. Our ancient ancestors found it very valuable to become instantly alert when a saber-toothed tiger suddenly sprang into their peripheral vision. As I'm sure you're aware, flickering objects on a screen can be quite annoying and thus should usually be avoided. Still, there are occasions when flicker is useful. This is especially true for dashboards that are constantly updated with real-time data and are used to monitor operations that require immediate responses.

Perhaps you've noticed that I've specified "2-D" position—an object's location relative to the vertical and horizontal dimensions only—and have ignored 3-D position, also known as *stereoscopic position*. 3-D position is also a preattentive attribute, but the pseudo-3-D effect that can be produced on the flat surface of a computer screen comes with a bevy of perceptual problems that complicate its use. 3-D elements are so rarely necessary to communicate business information and so difficult to design effectively that I recommend that you avoid using them altogether.

Encoding Quantitative Versus Categorical Data

Some of the preattentive attributes that we've examined can be used to communicate quantitative data, while others can be used only to communicate categorical data. That is, while some attributes allow us to perceive one thing as greater than others in some way (bigger, taller, more important), others merely indicate that items are distinct from one another, without any sense of some being greater than or less than others. For example, different shapes can be perceived as distinct, but only categorically. Squares are not greater than triangles or circles—they're just different. The following table again lists each of the preattentive attributes and indicates which are quantitatively perceived:

Category	Attribute	Quantitative
Color	Hue	No
	Intensity	Yes, but limited
Position	2-D position	Yes
Form	Orientation	No
	Line length	Yes
	Line width	Yes, but limited
	Size	Yes, but limited
	Shape	No
	Added marks	No
	Enclosure	No
Motion	Flicker	Yes, based on speed, but limited

You might argue that we can perceive orientation and curvature quantitatively, but there is no natural association of greater or lesser value with different orientations or degrees of curvature (for example, which is greater, a vertical or horizontal line?).

We can use those attributes with quantitative perception described as "Yes, but limited" to encourage perception of one thing as greater than, equal to, or less than another, but not with any degree of precision. For example, in Figure 4-7, it is obvious that the circle on the right is bigger than the circle on the left, but how much bigger? If the area of the small circle equals a value of one, what is the value of the bigger circle's area?

Figure 4-7. This illustrates our inability to assign precise quantitative values to objects of different sizes.

5

ELOQUENCE THROUGH SIMPLICITY

Now that you're familiar with some of the science behind dashboard design, it's time to take a look at a few strategies you can employ to create effective displays. The guiding principle in dashboard design should always be simplicity: display the data as clearly and simply as possible, and avoid unnecessary and distracting decoration.

Characteristics of a well-designed dashboard

Reducing the non-data pixels

Enhancing the data pixels

In earlier chapters, we concentrated on what doesn't work. Now it's time to shift our focus to what does, beginning with the design process itself—the goals and steps necessary to produce dashboards that inform rapidly with impeccable clarity.

Characteristics of a Well-Designed Dashboard

The fundamental challenge of dashboard design involves squeezing a great deal of useful and often disparate information into a small amount of space, all the while preserving clarity. This certainly isn't the only challenge—others abound, such as selecting the right data in the first place—but it is the primary challenge that is particular to dashboards. Limited to a single screen to keep all the data within eye span, dashboard real estate is extremely valuable: you can't afford to waste an inch. Fitting everything in without sacrificing meaning doesn't require muscles, it requires finesse.

Figure 5-1. The fundamental challenge of dashboard design is to effectively display a great deal of often disparate data in a small amount of space.

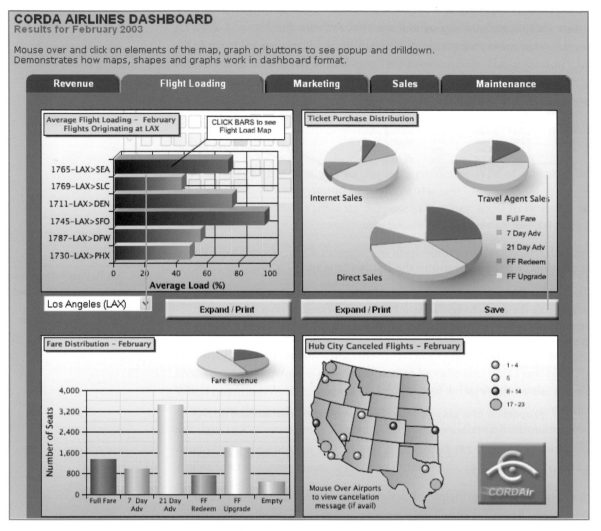

Figure 5-4. This dashboard displays an excessive amount of non-data pixels.

The non-data pixels that you could easily eliminate without any loss of meaning include:

- The third dimension of depth on all the pie charts and on the bars in the upper bar graph
- The grid lines in the bar graphs
- The decoration in the background of the upper bar graph
- The color gradients in the backgrounds of the graphs, which vary from white at the top through shades of blue as they extend downward

Some of the data pixels on this dashboard could also be removed without a loss of useful meaning—we'll come back to that in a moment.

Reducing the non-data pixels to a reasonable minimum is a key objective that places us on the path to effective dashboard design. Much of visual dashboard design revolves around two fundamental goals:

1] Reduce the non-data pixels.
2] Enhance the data pixels.

You start by reducing the non-data content as much as possible, and then proceed to enhance the data content with as much clarity and meaning as possible, working to make the most important data stand out above the rest (Figure 5-5).

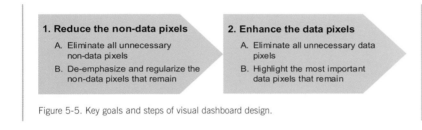

Figure 5-5. Key goals and steps of visual dashboard design.

Reduce the Non-Data Pixels

The goal of reducing the non-data pixels can be broken down into two sequential steps:

1] Eliminate all unnecessary non-data pixels.
2] De-emphasize and regularize the non-data pixels that remain.

Let's take a look at how to accomplish these two goals.

Eliminate all unnecessary non-data pixels

Dashboard design is usually an iterative process. You begin by mocking up a sample dashboard, and then you improve it through a series of redesigns, each followed by a fresh evaluation leading to another redesign, until you have it right. As you get better and better at this, the number of iterations that will be required will decrease, partly because you won't be including unnecessary non-data pixels in the first place. No matter how far you advance, however, the step of looking for unnecessary non-data pixels will never cease to be productive.

The next few figures provide examples of non-data pixels that often find their way onto dashboards but can usually be eliminated without loss.

Graphics that serve merely as decoration (Figure 5-6).

Figure 5-6. You should eliminate graphics that provide nothing but decoration.

Variations in color that don't encode any meaning (Figure 5-7).

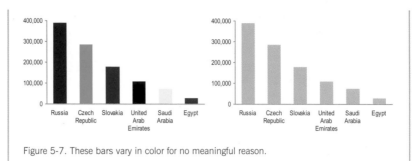

Figure 5-7. These bars vary in color for no meaningful reason.

Borders that are used to delineate sections of data when the simple use of white/blank space alone would work as well (Figure 5-8).

Figure 5-8. Unnecessary borders around sections of data fragment the display.

Fill colors that are used to delineate sections of content such as a title, the data region or legend of a graph, the background of a table, or an entire section of data, when a neutral background would work as well (Figure 5-9).

Figure 5-9. Fill colors to separate sections of the display are unnecessary.

Gradients of fill color when a solid color would work as well (Figure 5-10).

Figure 5-10. Gradients of color both on the bars of this graph and across the entire background add distracting non-data pixels.

Grid lines in graphs (Figure 5-11).

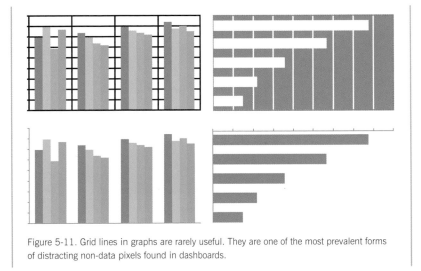

Figure 5-11. Grid lines in graphs are rarely useful. They are one of the most prevalent forms of distracting non-data pixels found in dashboards.

Grid lines in tables, which divide the data into individual cells or divide either the rows or the columns, when white space alone would do the job as well (Figure 5-12).

Salesperson	Jan	Feb	Mar	Salesperson	Jan	Feb	Mar
Robert Jones	2,834	4,838	6,131	Robert Jones	2,834	4,838	6,131
Mandy Rodriguez	5,890	6,482	8,002	Mandy Rodriguez	5,890	6,482	8,002
Terri Moore	7,398	9,374	11,748	Terri Moore	7,398	9,374	11,748
John Donnelly	9,375	12,387	13,024	John Donnelly	9,375	12,387	13,024
Jennifer Taylor	10,393	12,383	14,197	Jennifer Taylor	10,393	12,383	14,197
Total	$35,890	$45,464	$53,102	Total	$35,890	$45,464	$53,102

Figure 5-12. Grid lines in tables can make otherwise simple displays difficult to look at.

Fill colors in the alternating rows of a table to delineate them when white space alone would work as well (Figure 5-13).

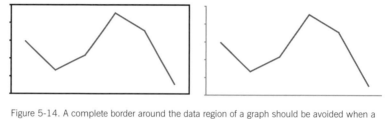

Sell				
Metric	Alerts ▽	Result ▽	Alert Spec ▽	Last Update ▽
QTD Sales ($MM)	2	● $ 153.0	$ 166.0	1/21/02
QTD Average Daily Order Rate (ADOR) ($MM)	1	◉ $ 16.1	$ 11.9	1/21/02
Previous Day's Orders ($MM)	0	◉ $ 26.2	$ 11.9	1/21/02
QTD % e-Orders	3	● 53.0%	59.0%	1/21/02
Current Qtr Price vs Target ($/lb)	6	◉ $ 1.27	$ 1.20	1/21/02

Figure 5-13. Fill colors should be used to delineate rows in a table only when this is necessary to help viewers' eyes track across the rows.

Complete borders around the data region of a graph when one horizontal and one vertical axis would sufficiently define the space (Figure 5-14).

Figure 5-14. A complete border around the data region of a graph should be avoided when a single set of axes would adequately define the space.

3D in graphs when the third dimension doesn't correspond to actual data (Figure 5-15).

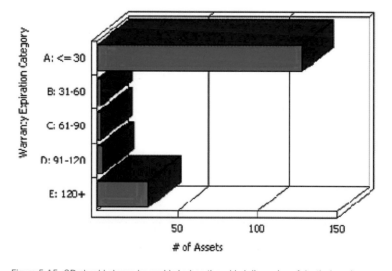

Figure 5-15. 3D should always be avoided when the added dimension of depth doesn't represent actual data.

Visual components or attributes of a display medium that serve no purpose but to make it look more like a real physical object or more ornate (Figure 5-16).

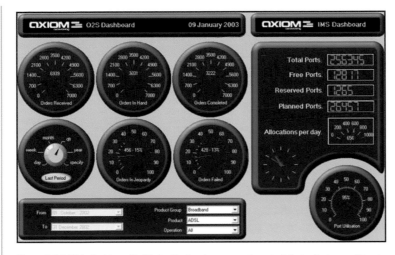

Figure 5-16. This dashboard is filled with visual components and attributes that serve the sole purpose of simulating real physical objects.

This is by no means a comprehensive list, but it does cover much of the non-data content that I routinely run across on dashboards. When you find that you've included useless non-data pixels such as those in any of the above examples, simply remove them.

De-emphasize and regularize the non-data pixels that remain

Not all non-data pixels can be eliminated without losing something useful. Some support the structure, organization, or legibility of the dashboard. For instance, when data is tightly packed, sometimes it is necessary to use lines or fill colors to delineate one section from another, rather than white space alone. In these cases, rather than eliminating these useful non-data pixels, you should simply mute them visually so they don't attract attention. Focus should always be placed on the information itself, not on the design of the dashboard, which should be almost invisible. The trick is to de-emphasize these non-data pixels by making them just visible enough to do their job, but no more.

Beginning on the next page are a few examples of non-data pixels that are either always or occasionally useful. I've shown each of these examples in two ways: 1) a version that is too visually prominent, which illustrates what you should avoid; and 2) a version that is just visible enough to do the job, which is the objective.

Another category of content often found on dashboards that can be considered non-data pixels is that which supports navigation and data selection. Buttons and selection boxes are often used to allow users to navigate to another screen or to choose the data that appears on the dashboard (for example, by selecting a different subset, such as hardware rather than software). These elements might serve an important function, but they don't display data. As such, they should not be given prominence. If they must exist, place them in an out-of-the-way location such as the bottom-right corner of the screen and mute them visually, so they won't compete with the data for attention. Notice how much of the dashboard in Figure 5-22 is dedicated to buttons and data selection controls, which I've highlighted with red borders. These elements take up far more valuable and prominent real estate on the dashboard than is required.

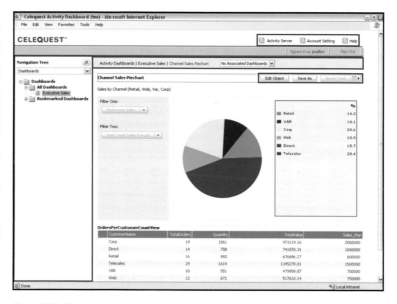

Figure 5-22. This dashboard gives navigational and data selection controls far more dominance and space than they deserve.

Similarly, while it may sometimes be necessary to include on the dashboard instructions that provide important support information, any nonessential text just takes up space that could be used by data, attracts attention away from the data, and clutters the dashboard's appearance. It usually works best to place most instructional or descriptive content either on a separate screen that can easily be reached when needed or, if possible, in the form of pop-ups that can be accessed when necessary with a click of the mouse. Notice how much prime real estate is wasted on the dashboard in Figure 5-23 to provide instructions that viewers will probably only need the first time they use the dashboard.

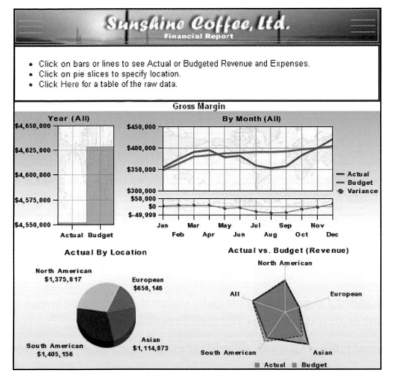

Figure 5-23. As you can see in the area highlighted in red, this dashboard uses up valuable space to display instructions that could have been provided only when needed through a separate screen or a pop-up menu.

Enhance the Data Pixels

Just like the reductionof non-data pixels, the process of enhancing the data pixels can be broken down into two sequential steps:

- Eliminate all unnecessary data pixels.
- Highlight the most important data pixels that remain.

Let's examine these two tasks.

Eliminate all unnecessary data pixels

When you're designing a dashboard, it is tempting to throw everything you think anyone could ever possibly want onto it. Those of us who have worked in the field of business intelligence for a while have grown weary of being asked for more (always more!), so the thought of heading off this demand by giving folks everything up front can be appealing. On a dashboard, however, where immediate insight is the goal, this is a costly mistake. I'm not suggesting that you force people to get by with less than they really need, but rather that you honor the consideration of what they *really need* for the task at hand as a strict criterion for the selection of

6

EFFECTIVE DASHBOARD DISPLAY MEDIA

Dashboards must be able to condense a lot of information onto a single screen and present it at a glance without sacrificing anything important or compromising clarity. Consequently, they require display media that communicate effectively, despite these conditions. Every section of data on a dashboard should be displayed using the clearest and richest possible means, usually in a small amount of space. This requires an available library of display media that have been selected, customized, and sometimes created especially for dashboards, and an understanding of the circumstances in which each medium of display should be applied.

A dashboard must be built using appropriately chosen and designed display media to reach its unique potential for clear and immediate communication. We'll begin this chapter with some basic guidelines for matching your data and message to the right form of display, and then proceed to the heart of the chapter: the description of a full library of display media that are ideal for dashboards.

Select the Best Display Medium

The best medium for displaying data will always be based on the nature of the information, the nature of the message, and the needs and preferences of the audience. A single dashboard generally displays a variety of data and requires a variety of display media, each matched to specific data. In the next section we'll pair specific data and messages with the graphic media that display them best, but let's begin here with a more fundamental question: "Should the information be encoded as text, graphics, or both?" The appropriateness of each medium for a given situation, either verbal language in written form (text) or visual language (graphics), isn't arbitrary.

Verbal language is processed serially, one word at a time. Some people are much faster readers than others—an ability that I envy—but everyone processes language serially. Especially when communicating quantitative information, the strength of written words and numbers compared to graphics is their precision. If your sole purpose is to precisely communicate current year-to-date expenses of $487,321, for example, nothing works better on a dashboard than a simple display like this:

YTD Expenses $487,321

Displaying individual values does not require graphics—indeed, their use would only retard communication. Let's continue to enhance this data to see if there is a point where switching from pure text to the addition of graphics adds clear value.

values to one another, while the line graph does a much better job of revealing the overall shape of the distribution.

Figure 6-20. These two graphs—one a bar graph and one a line graph—display exactly the same data but highlight different aspects of it.

Because bar graphs emphasize individual values, they also enable easy comparisons between adjacent values. Figure 6-21 illustrates the ease with which you can compare measures—in this case the productivity of the daytime and the nighttime crews in any given month—using this type of graph.

Figure 6-21. Bars are preferable to lines for encoding data along an interval scale—in this case, a time series divided into months—when the graph is intended to support comparisons of individual measures.

Even when you wish to display values that represent parts of a whole, you should use a bar graph rather than the ever-popular pie chart. This will present the data much more clearly—just be sure to indicate somewhere in text (for example, in the graph's title) that the bars represent parts of a whole. Figure 6-22 provides an example of both a pie chart and a bar graph used to present the same part-to-whole data. Notice how much

easier it is to make accurate visual judgments of the relative sizes of each part in the bar graph.

Figure 6-22. You can use a bar graph to more clearly display the same part-to-whole data that is commonly displayed with a pie chart.

Stacked bar graphs

A variation of the bar graph that is sometimes used to display business data is the *stacked bar graph*. This type of graph is useful for certain purposes, but it can easily be misused. I recommend against ever using a stacked bar graph to display a single series of part-to-whole data. A regular bar graph works much better. As you can see, it is much harder and more time-consuming to read the stacked bar graph in Figure 6-23 than the bar graph showing the same data in Figure 6-22.

Figure 6-23. A stacked bar graph is not the best way to display a single series of part-to-whole data.

regions without displaying the data on a map (see Figure 6-55), but displaying concentrations of absenteeism among employees in stores located throughout the United States on a map could reveal patterns related to location that might not be obvious otherwise.

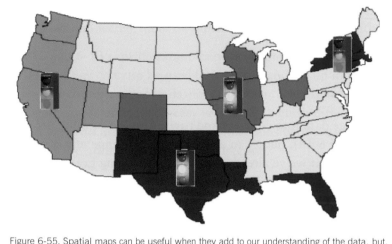

Figure 6-55. Spatial maps can be useful when they add to our understanding of the data, but, as in this case, they are often used unnecessarily.

The second most useful type of spatial map on a dashboard is probably the floor plan of a building. If, for example, it is your job to monitor temperatures throughout a large building and respond whenever particular areas exceed established norms, seeing the temperatures arranged on a floor plan could bring relationships between adjacent areas to light that you might miss otherwise.

Small multiples

The last organizer arranges graphs in a manner that Edward Tufte calls "small multiples." This arrangement is tabular, consisting of a single row or column of related graphs, or multiple rows and columns of related graphs arranged in a matrix. I list small multiples separately from tables because organizers that display small multiples ought to have some intelligence built into them to handle aspects of this arrangement that would be time-consuming to arrange manually in a table.

In a display of small multiples, the same basic graph appears multiple times, each time differing along a single variable. Let's look at an example. If you need to display revenue data as a bar graph across four sales regions, with bookings and billings revenue shown separately, you could do so in a single graph, as shown in Figure 6-56.

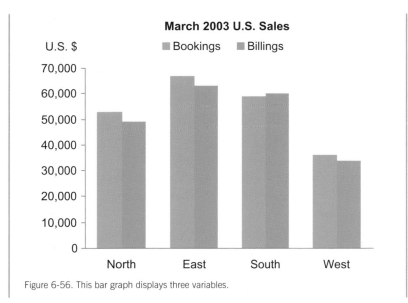

Figure 6-56. This bar graph displays three variables.

If, however, you must simultaneously display the revenue split between three sales channels (for example, sold directly, through distributors, and through resellers), a single graph won't work. To the rescue comes the small multiples display. As shown in Figure 6-57, by arranging three versions of the same graph next to one another—one graph per sales channel—you can show the entire picture within eye span, making comparisons easy. To eliminate unnecessary redundancy, you could avoid repeating the region labels in each graph, as well as the legend and the overall title. This not only saves valuable space, which is always important on a dashboard, but it also reduces the amount of information that the viewer must read when examining the display.

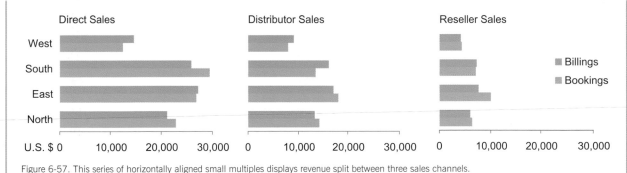

Figure 6-57. This series of horizontally aligned small multiples displays revenue split between three sales channels.

An intelligent organizer for small multiples built into the software would allow you to reference the data, indicate which variable goes on which axis of the graph, which should be encoded as lines of separate colors,

which should vary per graph, and finally whether you want the graphs to be arranged vertically, horizontally, or in a matrix; the organizer would then handle the rest for you. As of this writing, I have yet to see dashboard software that makes this easy to do. I reserve the hope, however, that this will soon change.

Summary

The library of dashboard display media that I've proposed in this chapter is certainly not comprehensive, nor will it remain unchanged as time goes on. As new graphic inventions emerge that suit the purpose and design constraints of dashboards, this library will continue to grow, but I expect that it will do so slowly. Just because a vendor introduces a new visualization technique doesn't mean it belongs on a dashboard. Let's keep the vision true to form and effective for enlightening and efficient communication.

7

DESIGNING DASHBOARDS FOR USABILITY

A few important aspects of a dashboard's visual design remain to be considered. One of the most challenging is the need to arrange many items of information—often related solely by the viewer's need to monitor them all—in a manner that doesn't result in a cluttered mess. This arrangement must support the intrinsic relationships between the various items and the manner in which they must be navigated and used to support the task at hand. A dashboard's design must optimally and transparently support its use. The whole also must be pleasing to look upon, or it will be ignored.

Organize the information to support its meaning and use

Maintain consistency for quick and accurate interpretation

Make the viewing experience aesthetically pleasing

Design for use as a launch pad

Test your design for usability

Beyond selecting appropriate display media and reducing the non-data pixels to a minimum, attention also must be given to several other aspects of design to guarantee that your dashboards are easy to use and do everything they can to support the viewer's need to respond to the information. Having knowledge of a few more design strategies under your belt will help you blend all the visual aspects of your dashboard into a pleasing and functional display.

Organize the Information to Support Its Meaning and Use

You can't just take information and throw it onto the dashboard any way you please. How the pieces are arranged in relation to one another can make the difference between a dashboard that works and one that ends up being ignored, even though the information they present is the same. Keep the following considerations in mind when you determine how to arrange data on the screen:

- Organize groups according to business functions, entities, and use.
- Co-locate items that belong to the same group.
- Delineate groups using the least visible means.
- Support meaningful comparisons.
- Discourage meaningless comparisons.

Organize Groups According to Business Functions, Entities, and Use

A good first cut at organizing data is to form groups that are aligned with business functions (for example, order entry, shipping, or budget planning), with entities (departments, projects, systems, etc.), or with uses of the data (for instance, the need to compare revenues and expenses). These are the natural ways to organize most business data.

8

A great deal of information has been amassed as the lessons in this book have been unveiled step by step, concept by concept, and principle by principle. Now it is time to tie it all together, to see these principles combined in the form of sample dashboards. The proof is in the efficacy of the result: dashboards that can be monitored and understood at a glance. We'll look at four examples of effectively designed dashboards, and put our knowledge to the test by critiquing eight alternate solutions to one of these design problems.

In this final chapter, we'll bring together the principles and practices taught throughout the book. We'll examine some dashboards that illustrate the clear and efficient communication that results from informed design, and we'll test your knowledge by critiquing several others. These samples address four different business scenarios, including dashboards that support strategic, analytical, and operational purposes:

Sample sales dashboard A sales manager might use this dashboard to monitor sales performance and opportunities (strategic).

Sample CIO dashboard A Chief Information Officer (CIO) might use this dashboard to monitor several aspects of a company's information systems (strategic and operational).

Sample telesales dashboard The supervisor of a team of sales representatives who take orders and answer questions by phone might use this dashboard to monitor performance (operational).

Sample marketing analysis dashboard A marketing analyst might use this dashboard to monitor the marketing performance of the company's web site (analytical).

These examples will not only put flesh on the bones of the design principles that I've taught in this book, but (I hope) will also suggest ideas for the types of information you might display on a dashboard and some interesting and effective ways to do so.

Critique of Sales Dashboard Example 1

SALES DASHBOARD - 19 December 2004

Performance
Good
Satisfactory
Poor

		Actual Q1	Actual Q2	Actual Q3	To Date Q4	Forecast Q4	Target Q4
Revenue Total		$ 154,057	$ 165,158	$ 199,738	$ 206,264	$ 225,205	$ 215,000
by Region	North America	$ 78,963	$ 78,138	$ 91,176	$ 91,441	$ 100,197	$ 107,500
	Europe	$ 30,811	$ 33,032	$ 39,948	$ 41,253	$ 45,374	$ 43,000
	Asia	$ 28,877	$ 37,472	$ 48,641	$ 52,944	$ 57,380	$ 39,775
	South America	$ 3,041	$ 3,435	$ 4,206	$ 5,035	$ 5,738	$ 5,375
	Middle East	$ 12,365	$ 13,081	$ 15,767	$ 15,592	$ 16,515	$ 19,350
by Product	Cabernet	$ 28,430	$ 30,228	$ 35,053	$ 38,728		$ 38,700
	Zinfandel	$ 13,876	$ 10,164	$ 17,876	$ 18,664		$ 19,350
	Merlot	$ 25,440	$ 24,977	$ 28,955	$ 28,865		$ 36,550
	Chardonnay	$ 68,634	$ 64,025	$ 104,063	$ 107,610		$ 98,900
	Sauvignan Blanc	$ 17,677	$ 35,763	$ 13,790	$ 12,350		$ 21,500
Profit		$ 31,999	$ 36,749	$ 42,431	$ 46,685		$ 53,750
Avg Order Size		405	421	435	449		430
Market Share		23%	20%	19%	17%		27%
Customer Satisfaction		3.18	2.95	2.82	2.67		3.29
On-Time Delivery		83%	73%	65%	68%		95%
New Customers		346	430	447	468		450

Figure 8-2. This text-based sample sales dashboard could be improved.

This sales dashboard uses an approach that relies almost entirely on text to communicate, using visual means only in the form of green, light red, and vibrant red hues to highlight items as "good," "satisfactory," or "poor." Expressing quantitative data textually provides precise detail, but this isn't usually the purpose of a dashboard. Dashboards are meant to provide immediate insight into what's going on, but text requires reading—a serial process that is much slower than the parallel processing of a visually oriented dashboard that makes good use of the preattentive attributes of visual perception.

To compare actual measures to their targets, mental math is required. Graphical support of these comparisons would have been easier and faster to interpret.

Numbers have been center-justified in the columns, rather than right-justified. This makes them harder to compare when scanning up and down a column.

Some important measures are missing. This dashboard does not include pipeline revenue or the top 10 customers.

All four quarters of the current year have been given equal levels of emphasis. A sales manager would have greater interest in the current quarter. The design of the dashboard should have focused on the current quarter and comparatively reduced emphasis on the other quarters.

Proper care has not been given to make important distinctions. The greater intensity of the vibrant red hue that is used to highlight measures that are performing poorly will stand out clearly even to color-blind users, but the subdued shade of red and the equally subdued shade of green might not be distinguishable. Also, the numbers that ought to stand out most and be very easy to read—the poorly performing measures—are the hardest to read against the dark red background.

Critique of Sales Dashboard Example 2

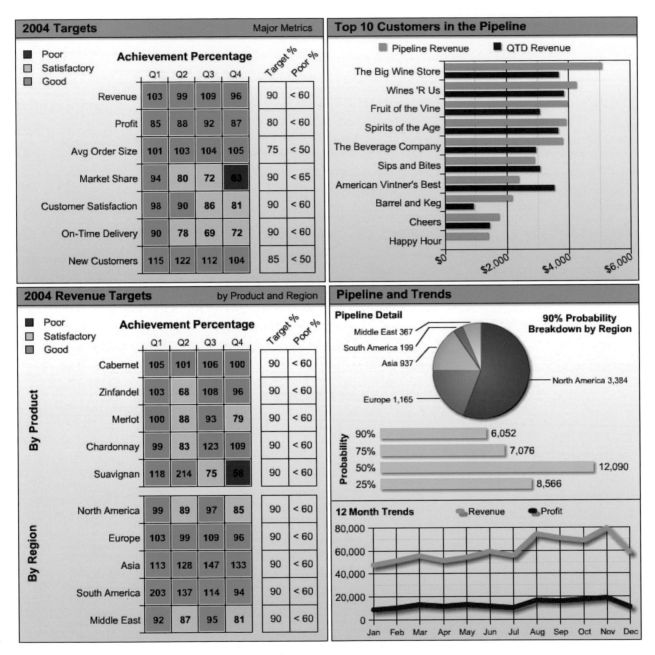

Figure 8-3. This solution exhibits some of the same problems as the previous example, but also a few different ones.

The grid lines that appear in the tables are not needed at all. Even if they were needed, they should have been muted visually. In their current heavy form, they imprison the numbers.

The grid lines that appear in the graphs are also unnecessary. They distract from the data. Especially in the context of a dashboard, you can't afford to include any unnecessary visual content.

The drop shadows on the bars and lines in two of the graphs and on the pie chart are visual fluff. These elements serve only to distract.

All of the numbers in the tables have been expressed as percentages. If those who use this dashboard only care about performance relative to targets, this is fine, but it is likely that they will want a sense of the actual amounts as well.

The pie chart is not the most effective display medium. Assuming that it is worthwhile to display how the 90% probability portion of the revenue pipeline is distributed among the regions, a bar graph with the regions in ranked order would have communicated this information more effectively.

Overall, this dashboard exhibits too many bright colors. The dashboard as a whole is visually overwhelming and fails to feature the most important data.

There is no comparison of trends in the revenue history. The 12-month revenue history shown in the line graph is useful, but it would also have been useful to see this history per region and per product, to allow the comparison of trends.

Critique of Sales Dashboard Example 3

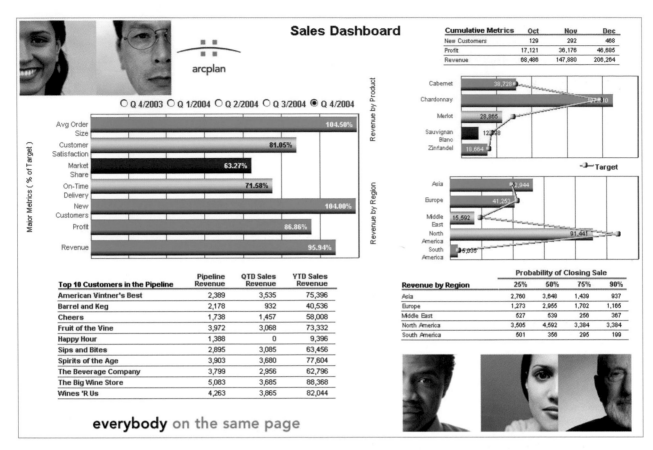

Figure 8-4. This solution illustrates several of the problems that I pointed out in Chapter 3, *Thirteen Common Mistakes in Dashboard Design*.

This design fragments the data that a sales manager would want to see into separate instances of the dashboard. Notice the radio buttons above the graph on the left, which are used to select the quarter that you want to see. This gives you no means to compare sales performance over time.

The photographs are chartjunk (a term coined by Edward Tufte to describe visual content in an information display that serves only as decoration). This useless decoration serves only to distract from the data. After seeing these faces for a couple of days, viewers will tire of them and wish the space had been better used. Furthermore, the most important real estate on the screen (at the top left) is taken up by photographs and a company logo. This is a waste of valuable space.

The bar graph in the upper left fails to visually display clear comparisons to the targets. You must read the numbers printed on the bars to determine the relationships to the targets.

The two graphs on the right make an attempt to visually compare the revenue measures to their targets, but they use a line to encode the targets, which is inappropriate for this data. Using a line to connect values in a graph suggests a relationship of change between the values, but revenue values for individual products or regions are not intimately connected to one another—they are discrete values along a nominal scale. The patterns formed by the lines are meaningless.

Critique of Sales Dashboard Example 4

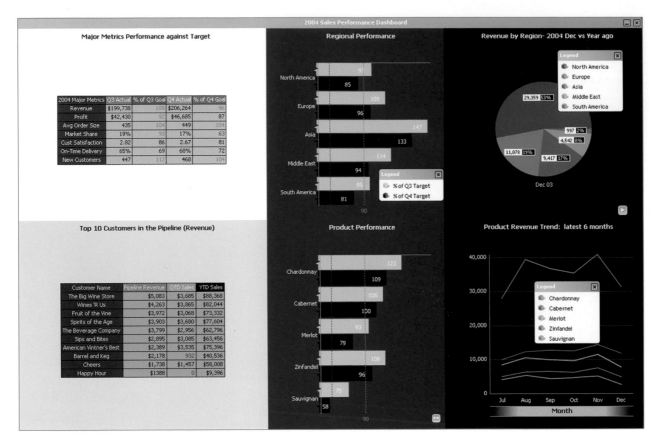

Figure 8-5. This example used headache-inducing colors.

The use of color is too dramatic, especially in the areas with the dark backgrounds. A light, slightly off-white background throughout would have worked better. Also, the use of extremely different background colors to separate the data into four sections isn't necessary.

White space is overused. Rather than surrounding the two tables on the left in a large amount of white space, the tables could have been enlarged to make them easier to read.

Critique of Sales Dashboard Example 5

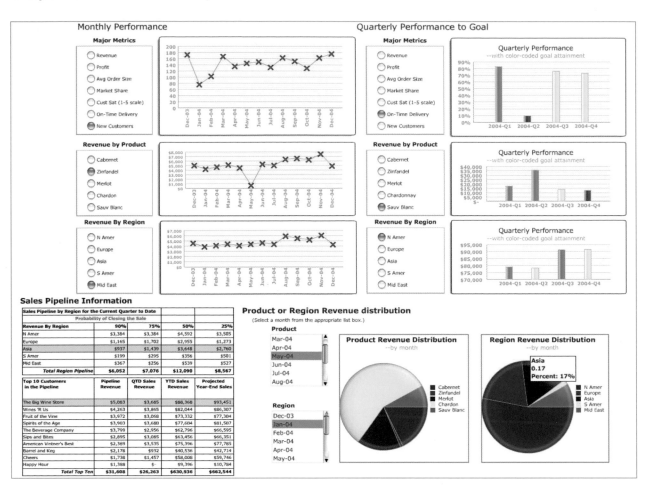

Figure 8-6. This solution exhibits some of the problems found in previous examples, and a few others.

Once again, we have a design that has fragmented the data. Notice the radio buttons or sliders next to each of the graphs. We can only see one measure at a time in each graph, yet much of this data ought to be displayed together to enable us to make useful comparisons (such as between the regions).

The beautiful, brightly colored pie charts look so much like candy, I get a sugar-rush just looking at them. The colors are much too bright, and the photo-realistic shading to give them a 3-D appearance is simply not necessary. This effect makes the pie charts jump out as the dominant features of the dashboard, which is not warranted. Also, once again, pie charts are not the most effective means of displaying data on a dashboard, because they don't allow for comparisons as easily as bar graphs.

The visual shading on the bars and buttons, like that on the pie charts, is unnecessary and distracting. This contributes to the effect of making these objects pop out inappropriately.

Critique of Sales Dashboard Example 6

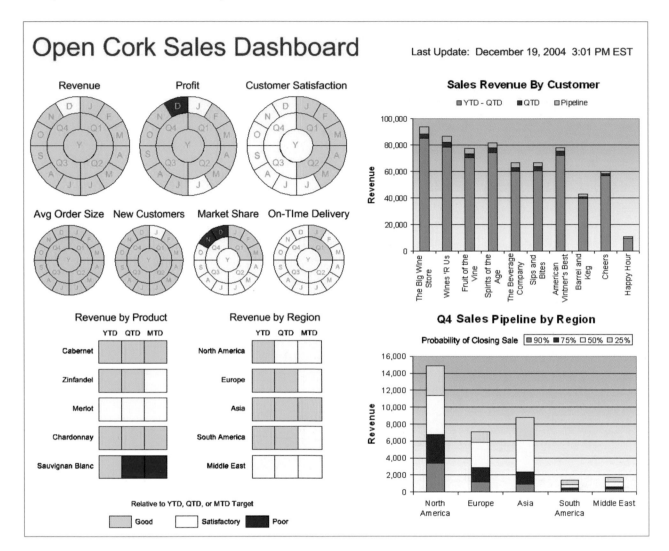

Figure 8-7. While visually appealing in some ways, this solution has some serious weaknesses.

Despite the visual appeal of the left half of this dashboard, the display media were not well chosen. The circular representations of time-series data using hues to encode states of performance (good, satisfactory, and poor) are clever, but for the purpose of showing history, these are not as intuitive or informative as a linear display, such as a line graph.

None of the measures that appear on the left side of the dashboard is revealed beyond its performance state. Knowing the actual revenue amount and more about how it compares to the target would certainly be useful to a sales manager. Unlike some of the previous examples that used hues to encode states of performance, however, I believe that these hues were carefully chosen to be recognizable by those who are color-blind.

The circular display mechanisms treat all periods of time equally. There is no emphasis on the current quarter.

Gradient fill colors in the bar graphs add meaningless visual interest. They also influence perception of the values encoded by the bars in subtle ways. Bars that extend into the darker sections of the gradient appear slightly different from those that extend only into the lighter sections. Dashboard designers should be conscious of even these subtle effects and avoid them.

Critique of Sales Dashboard Example 7

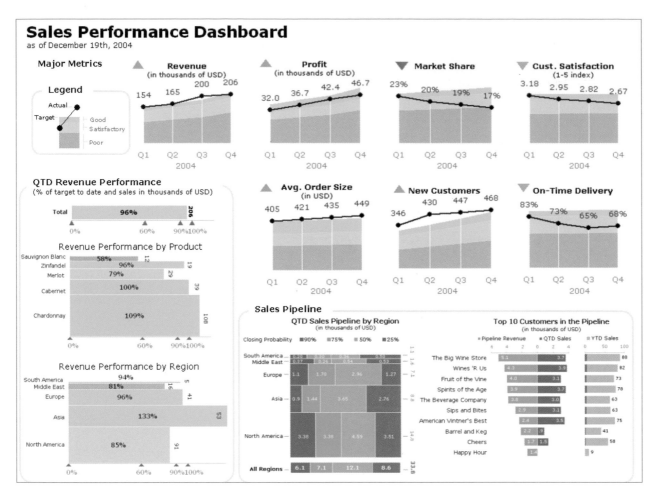

Figure 8-8. This dashboard has a problem that we haven't seen so far that undermines its effectiveness.

Some of these graphs are too complex for easy interpretation. The revenue performance by product and region graphs at the lower left and the quarter-to-date sales pipeline by region graph in the center bottom position all use bars that encode values in two dimensions, using both the height and width of each bar. This is a worthwhile attempt to save space, but one that requires too much study to interpret due to limitations in visual perception. The two graphs on the left both use the X (horizontal) axis to encode revenue performance compared to target, and the Y (vertical) axis to encode the portion of each product or region to the whole, functioning like stacked bar graphs. The pipeline revenue graph in the center displays the different parts of the pipeline (90% probability, etc.) as segments of the bar running horizontally from left to right, and the regional portions of the total pipeline as vertical segments. Using both the height and width of the bars to encode quantitative values—rectangles that tempt us to compare their 2-D areas to one another—results in inaccurate comparisons.

Critique of Sales Dashboard Example 8

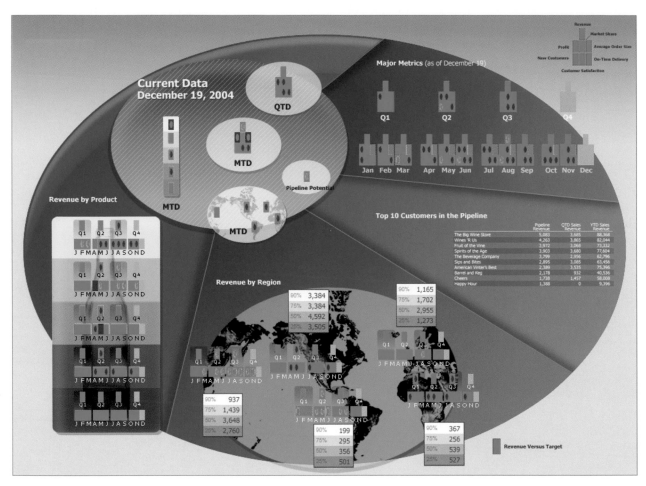

Figure 8-9. This final example is quite a departure from the others and has some serious (and probably obvious) flaws.

This dashboard, while an interesting contrast to the others, is confusing at first glance and likely to remain that way for some while. Much of the data it presents is also fairly imprecise. Colors and shapes have been used to encode values in the rectangles that appear throughout the dashboard. In the upper-right corner, you find a legend that tells you what each of the rectangles represents (revenue, market share, profit, etc.) wherever you see them arranged in this particular configuration. Although a key for the meaning of the various colors and shapes that appear in the rectangles does not appear on the dashboard, the key shown in Figure 8-10 was provided separately when it was submitted for the competition. You could certainly memorize the meanings of the various rectangle locations and of the colors and shapes inside them, but even after that effort, these rectangles would still never give you more than a rough sense of how the measures compare to their targets. For instance, seeing these measures encoded in this way and arranged side by side to represent months or quarters does not come close to providing the understanding of historical trend that a simple line graph could convey.

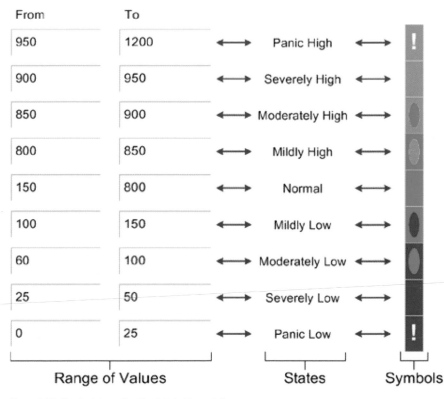

From	To	States	Symbols
950	1200	Panic High	
900	950	Severely High	
850	900	Moderately High	
800	850	Mildly High	
150	800	Normal	
100	150	Mildly Low	
60	100	Moderately Low	
25	50	Severely Low	
0	25	Panic Low	

Range of Values

Figure 8-10. Key for interpreting the data in Figure 8-9.

Now that you've taken this little tour through several solutions to the same dashboard design challenge, go back and take a look once more at the dashboard in Figure 8-1. As you can see, there is an eloquence to data displayed simply that cannot be achieved if we stray from the essential goal of communication.

Sample CIO Dashboard

A Chief Information Officer must keep track of many facts regarding the performance of the company's information systems and activities, including projects that serve the company's information needs. I chose to include the following data in my sample dashboard:

- System availability (uptime)
- Expenses
- Customer satisfaction
- Severe problem count
- CPU usage relative to capacity
- Storage usage relative to capacity
- Network traffic
- Application response time
- Major project milestones
- Top projects in the queue
- Other critical events

This is a mixture of strategic and frequently updated operational information that a CIO might need. Examine Figure 8-11 closely and try to get a sense for how it might work in the real world.

Only one section of this dashboard—the upper-left corner—displays near real-time data. This section consists of a series of five alerts: one for each of the systems that the CIO might need to respond to immediately when a problem arises. If no red circles appear in this section, nothing critical is currently wrong with any of these systems. To better grab the CIO's attention, red alerts that appear in this section could blink until clicked, or even emit along with the blinks a sound that gradually increases in volume. The red alert objects could also serve as links to other screens that describe precisely what is wrong.

The rest of this dashboard provides the CIO with information that is more strategic in nature. Notice that a great deal of contextual information has been provided to complement the measures—especially comparisons to measures of acceptable performance. This is the kind of context that could help the CIO easily make sense of these measures.

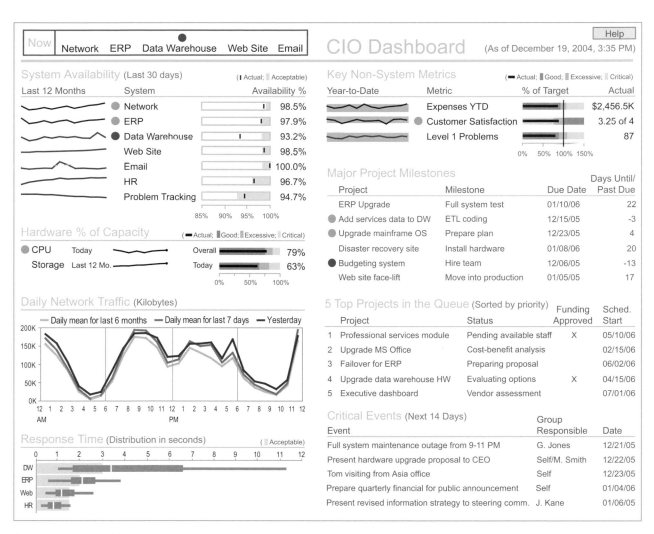

Figure 8-11. A sample CIO dashboard.

There is a great deal of information on this dashboard, yet it doesn't seem cluttered. This is largely due to the fact that non-data pixels have been reduced to a minimum. For instance, white space alone has been used to separate the various sections of the display. A judicious use of color has also contributed to this effect. Besides gray-scale colors, the only other hues you see are a muted green for the name of each section and two intensities of red, which in every case serves as an alert. It is easy to scan the dashboard and quickly find everything that needs attention, because the red alert objects are unique, visually unlike anything else.

Including information about project milestones, pending projects, and other critical events on this dashboard not only locates all the most important information the CIO needs in one place, but also supports useful

comparisons. Being reminded about coming events that might affect existing systems and being able to look immediately at the current performance of those systems could raise useful questions about their readiness.

Sample Telesales Dashboard

This sample dashboard was designed to monitor real-time operations so that a telesales supervisor can take necessary actions without delay. This isn't a dashboard that's likely to be looked at once a day, but one that will be kept available and examined throughout the day. It doesn't display as many measures as the examples you've seen so far in this chapter, because too many measures can be overwhelming when the dashboard is used to monitor real-time operations that require quick responses. Only the following six measures are included:

- Call wait time
- Call duration
- Abandoned calls (that is, callers who got tired of waiting and hung up)
- Call volume
- Order volume
- Sales representative utilization (representatives online compared to the number available)

That's it—and that's plenty for a dashboard of this type.

Imagine that you're responsible for a team of around 25 telesales representatives and are using the dashboard in Figure 8-12 to keep on top of their activities throughout the day.

The primary metrics that you must vigilantly monitor are the length of time customers are waiting to connect with a sales representative, the length of time sales representatives are spending on calls, and the number of customers who are getting discouraged and hanging up while waiting to get through. Because of their importance, these three metrics are located in the upper-left corner of the dashboard and are extremely easy to read.

When problems arise, such as the lengthy hold times and excessively lengthy calls shown in this example, you must quickly determine the cause before taking action. This is when you would switch your focus to the performance of the individual sales representatives, which you can see on the right side of the dashboard. Individuals are ranked by performance, with those performing poorly at the top and a red rectangle highlighting those who are performing outside the acceptable range.

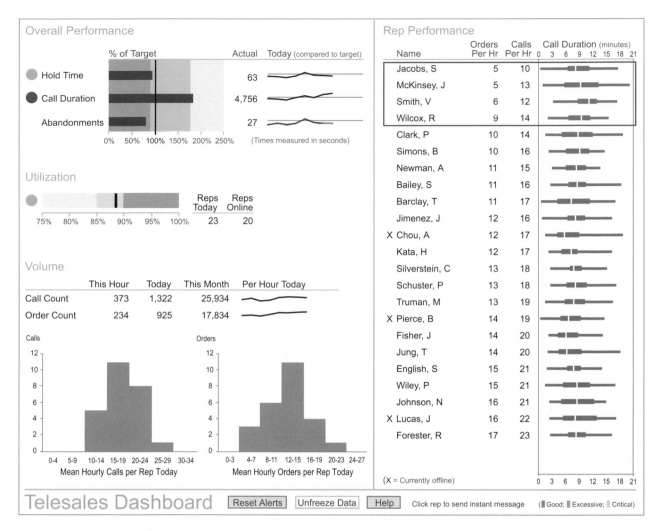

Figure 8-12. A sample telesales dashboard.

As a dashboard for monitoring real-time operations, the data would probably change with updates every few seconds. This can be distracting when you're trying to focus on a problem, however, so a "Freeze Data/Unfreeze Data" button has been provided to temporarily put a halt to updates. When updates are frozen, the button shines yellow to remind you of this fact. If the display remains frozen for too long, the button begins to blink with a brighter yellow until clicked to once again allow updates. When alerts first appear (the red circles), they blink to attract attention and perhaps even emit an audio signal to alert you if you aren't watching the screen. To stop these signals, you click the red alert. To remind you that you've blocked the alerts from providing urgent signals, the "Reset Alerts" button turns yellow, and after a while begins to blink. Once clicked, all alerts can once again signal urgent conditions if necessary.

Sample Marketing Analysis Dashboard

The last sample dashboard we'll look at is an example of one that supports analysis (Figure 8-13). Like all dashboards, it is used to monitor the information needed to do a job, but in this case that job happens to primarily involve analysis. Dashboards can provide a useful means for analysts to watch over their domains and spot conditions that warrant examination. Ideally, they can also serve as direct launch pads to the additional data and tools necessary to perform comprehensive analyses.

This particular scenario involves an analyst whose work supports the marketing efforts of the company's web site. She monitors customer behavior on the site to identify both problems that prevent customers from finding and purchasing what they want and opportunities to interest customers in additional products. To expose activities on the web site that could lead to insight if studied and understood, the following data appears on the dashboard:

- Number of visitors (daily, monthly, and yearly)
- Number of orders
- Number of registered visitors
- Number of times individual products were viewed on the site
- Occasions when products that were displayed on the same page were rarely purchased together
- Occasions when products that were not displayed on the same page were purchased together
- Referrals from other web sites that have resulted in the most visits

The information that appears at the top of this dashboard provides an overview of the web site's performance through time and lists missed opportunities and ineffective marketing efforts. Notice that the time-series information regarding visitors to the site is segmented into three sections, each featuring a different interval of time. The intervals have been tailored to reveal greater detail for the recent past and increasingly less detail the farther back the data goes.

Much of the information on this dashboard has been selected and arranged to display a ranking relationship. This is common when a dashboard is used to feature exceptional conditions, both good and bad. Much of this ranked information is communicated in the form of text, with little graphical content. Given the purpose to inform the analyst of potential areas of interest with a brief explanation of why, text does the job nicely. The analyst must read each entry to decide if she'll investigate the matter, but graphical displays, which could be scanned faster, would not do the job as

well. The fact that an item appears on one of these lists already implies its importance, so graphical devices such as alerts would add nothing.

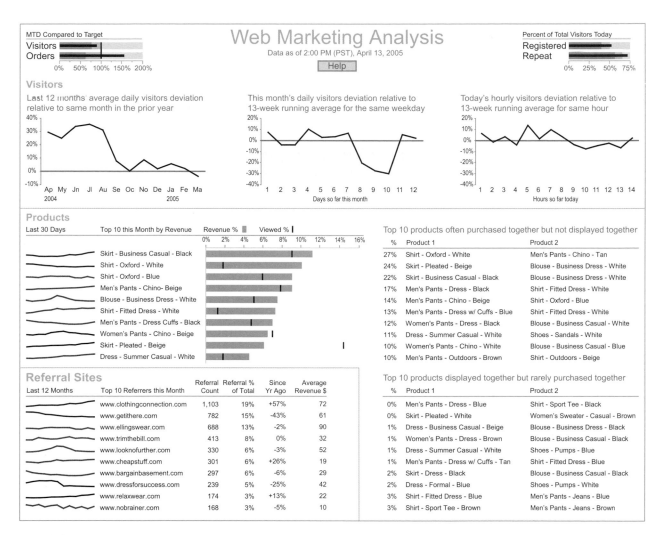

Figure 8-13. A sample web marketing analysis dashboard.

A Final Word

To design dashboards that really work, you must always focus on the fundamental goal: communication. More than anything else, you must care that the people who use your dashboards can look at them and understand them—simply, clearly, and quickly. Dashboards designed for any other reason, no matter how impressive or entertaining, will become tiresome in a few days and will be discarded in a few weeks—and few things are more discouraging than having your hard work tossed aside as useless.

When I design something that makes people's lives better, helps them work smarter, or gives them what they need to succeed in something that is important to them, I am reminded that one of the great cornerstones of a life worth living is the joy of doing good work. This doesn't just happen; it is the result of effort that you make because you care. Your dashboards may not change the world in any big way, but anything you do well will change you to some degree for the better. Even if the business goals that you're helping someone achieve through a well-designed dashboard don't ultimately matter to you or are not intrinsically worthy of great effort, you're worth the effort, and that's enough. In fact, that's plenty.

Books by three authors in particular stand out as complementary to the information that I've presented about dashboard design, and each deserves a place in your library:

Wayne W. Eckerson, Director of Research, The Data Warehousing Institute (TDWI).

Performance Dashboards: Measuring, Monitoring, and Managing Your Business (Indianapolis, IN: Wiley Publishing, Inc., 2005)

Wayne is one of the top industry analysts focused on business intelligence and data warehousing. In his book, he covers several aspects of dashboards that fall outside of my exclusive concentration on visual design, including how they can be used to improve business performance.

Edward R. Tufte, Professor Emeritus at Yale University

The Visual Display of Quantitative Information (Cheshire, CT: Graphics Press, 1983)

Visual Explanations (Cheshire, CT: Graphics Press, 1990)

Envisioning Information (Cheshire, CT: Graphics Press, 1997)

Beautiful Evidence (Cheshire, CT: Graphics Press, 2006)

No one in recent history has contributed more to our understanding of visual information display than Dr. Tufte. All of his books are beautifully designed, eloquently written, and overflowing with insights.

Colin Ware, Director of the Data Visualization Research Laboratory, University of New Hampshire

Information Visualization: Perception for Design, Second Edition (San Francisco, CA: Morgan Kaufmann Publishers, 2004)

What we know today about visual perception comes from the work of many researchers from many scientific disciplines, but Dr. Ware applies this knowledge to the visual presentation of information better than anyone else.

ABOUT THE AUTHOR

 Stephen Few has over 20 years of experience as an IT innovator, consultant, and educator. Today, as Principal of the consultancy Perceptual Edge, Stephen focuses on data visualization for analyzing and communicating quantitative business information. He is working to raise consciousness and to provide a treatment plan that addresses the needs of business in the language of business. His previous book, *Show Me the Numbers: Designing Tables and Graphs to Enlighten*, is a powerful fitness program designed to target the data presentation aspects of this problem.

Today, from his office in Berkeley, California, Stephen provides consulting and training services, speaks frequently at conferences, and teaches in the MBA program at the University of California in Berkeley. More about his current work can be found at *www.perceptualedge.com*.

COLOPHON

Genevieve d'Entremont was the production editor for *Information Dashboard Design*. Rachel Wheeler was the copyeditor. Claire Cloutier provided quality control. Specialized Composition, Inc. provided production services.

Stephen Few designed the cover of this book. Karen Montgomery produced the cover layout in Adobe InDesign CS, using Sabon and News Gothic Condensed fonts.

Mike Kohnke and Terri Driscoll designed the interior layout. The text font is Sabon, and the heading font is News Gothic Condensed. The original illustrations that appear in this book were produced by the author, Stephen Few, using Microsoft Excel and Adobe Illustrator CS.